The New Architecture of Qatar

The New Architecture of Qatar

Philip Jodidio

Preface by
H.E. Sheikha Al Mayassa bint Hamad bin Khalifa Al Thani
Chairperson of Qatar Museums Board of Trustees

Photography by
Roland Halbe

Preface

Over the past decades, Qatar has undergone rapid development. H.H. Sheikh Hamad bin Khalifa Al Thani, the Father Emir was keen to develop a modern state yet at the same time maintain Qatar's cultural and traditional values. As we continue to advance into the 21st century with the Emir H.H. Sheikh Tamim bin Hamad Al Thani, Qatar's National Vision 2030 remains a key blueprint for development. To support the realization of Qatar's plans for growth - construction in every sense of the word - from the social, economic, environmental and human points of view will be necessary to foster a culture of growth. When new buildings rise, they are reflective products of existing conditions — but also of plans and hopes for the future that is beyond what can be seen.

Architecture is thus the most visible aspect of a country's character, and here too, Qatar is in the forefront of a reasoned process of building, with clear goals in mind. The complex task of bringing tradition and modernity together in a significant work of architecture is nowhere more present than in the design of the Imam Muhammad Ibn Abdul Wahhab Mosque; a contemporary building inspired by forms that come from the Abu Al Qabib mosque. The Abu Al Qabib mosque was built in 1878 on the order of Sheikh Jassim bin Mohammed, founder of modern Qatar. Old buildings continue to inspire new architecture — with the Qatar National Museum building inspired by the Desert Rose reaching its final stages overlooking Souq Waqif. Similarly Musheirb's architectural development in downtown Doha has been inspired by the old souq while incorporating modern design.

As we look to the future, Qatar is moving its dependency from a carbon economy to a knowledge based society. In investing in the sectors of education, health and research Qatar is also considering the architectural developments to support these services. Education City, the Sidra Hospital, and the Aspire Zone complex are just a few examples of Qatar's architectural destination sites. When important projects are complemented with interesting architectural design we are inspired to think beyond four walls.

My thanks goes to the Father Emir, who has inspires us to build a city for future generations; gratitude also goes to HH the Emir for his leadership and focus on innovation at times of rapid change. I also would like to thank everyone who has contributed to the development of Qatar's economy. It is the effort of every one of us, from construction workers to architects, from design to execution, that continues to allow us to realize our vision.

Sheikha Al Mayassa bint Hamad bin Khalifa Al Thani
Chairperson of Qatar Museums Board of Trustees

Contents

Preface *p.* **14**
H.E. Sheikha Al Mayassa bint Hamad bin Khalifa Al Thani

Introduction *p.* **18**
Philip Jodidio

Museum of Islamic Art, *p.* **22**
Doha, 2008

Museum of Islamic Art Park, *p.* **38**
Phase 1, 2011

Weill Cornell Medical College in Qatar, *p.* **48**
Education City, 2003

Ceremonial Court, *p.* **60**
Education City, 2007

Imam Muhammad Ibn Abdul Wahhab Mosque, *p.* **68**
Al-Khuwair, Doha, 2011

Liberal Arts & Science Building, *Education City, 2004*	p. 80	Ministry of Finance, *Doha, 1984*	p. 222
Qatar National Convention Center, *Education City, 2011*	p. 90	Souq Waqif, *Doha, 2008*	p. 228
Doha Tower, *West Bay, Doha, 2011*	p. 100	Qatar University, *Doha, 1985*	p. 236
The New Emiri Diwan, *Doha, 1972 - 89*	p. 114	Mathaf: Arab Museum of Modern Art, *Education City, 2010*	p. 248
Hamad International Airport, *Doha, 2012*	p. 126	Georgetown University School of Foreign Service in Qatar, *Education City, 2010*	p. 256
Aspire Zone, *Doha, 2005*	p. 142	Al Wakrah & Lusail Heritage Villages, *2010*	p. 262
Al Shaqab, *Education City, 2011*	p. 154		
Qatar Science & Technology Park, *Education City, 2010*	p. 162		
		Map of Projects in Qatar	p. 279
Tornado Tower, *West Bay, Doha, 2009*	p. 172	Cultural Projects	p. 282
Katara Cultural Village, *Doha, 2010*	p. 180	Government Buildings & Health Facilities	p. 290
Sheraton Doha Hotel, *Doha, 1982*	p. 188	The Rise of Doha	p. 298
Student Center, *Education City, 2010*	p. 194	Educational Projects	p. 306
		Sports Facilities	p. 314
Carnegie Mellon University in Qatar, *Education City, 2008*	p. 202		
Texas A&M University at Qatar, *Education City, 2008*	p. 212	Notes	p. 318

Introduction

Development in Context

The New Architecture of Qatar

Contemporary architecture is often explained in formal terms—what is the shape of a building, what are its functions, how does it fit into the trends and styles of the moment? In the State of Qatar, recent years have seen some of the outstanding figures of architecture realize buildings worthy of international attention. And yet, this is not the most interesting aspect of the rapid transformation of the country, and the city of Doha in particular. Famous architects usually serve a specific client, creating unique structures destined to stand out from their environment. Contextual insertion is rarely a priority in these cases but efforts have advanced in recent years to theorize the relationship between contemporary architecture and local circumstances. There has been much debate in architectural circles about the virtues or faults of theories bearing names like "Critical Regionalism," where local design traditions are somehow integrated into the creation of contemporary buildings. The practical results of such theories are not obvious, and even works by top architects often continue to look as though they could have been built in New York, Tokyo, or, as now, Doha.

Beyond Appearance and Style

Context in Qatar has to do with such factors as the proximity of the desert and the sea, a climate that is harsh in summer months, and also, of course, with history. Nor is this history as brief as some might imagine. As recently as 2009, traces of an important early Holocene Neolithic-Chalcolithic settlement were discovered at Wadi Debayan in the northwest of the country. One of six Neolithic sites thus far uncovered in Qatar, the finds at Wadi Debayan imply occupation of the area more than 6,000 years ago. The discovery of fragments of Ubaid pottery (6500–4000 BC), probably manufactured in Mesopotamia, implies the involvement of the region with the trading and exchange networks that were already active at the time. Arabian Gulf trade, as well as fishing and later pearling were the sources of Qatar's livelihood for centuries. Awareness of this history, together with more recent evidence of Islamic architecture, are clues to the ways in which the rulers of Qatar have embarked on a unique experiment. In this spirit, the architecture of today serves a contextual purpose that goes well beyond formal issues of appearance or style. "What has been achieved in the past must be transformed into a living future," states Her Excellency Sheikha Al Mayassa bint Hamad Al Thani, Chairperson of Qatar Museums.

From the Dukhan Field to West Bay
The defining moment in the recent history of Qatar might be situated in 1940 with the discovery of oil in the Dukhan Field on the west coast of the peninsula. In 1971, Qatar won its independence and assumed full authority over all decisions related to oil. The same year Shell Qatar discovered the North Gas Field, the largest single natural non-associated gas field in the world. At the beginning of 2013, Qatar was estimated to hold the third largest reserves of natural gas and was the leading supplier in the world of liquefied natural gas. Combined with significant proven oil reserves, these natural resources do much to explain the considerable prosperity of the State of Qatar, and its rapid development since the 1970s.

The stunning cluster of high-rise buildings in the West Bay area of Doha shows even the most casual visitor that architecture is playing its role in the emergence of Qatar as a country that is more modern in some respects than many of its Western or Eastern counterparts. Aware that its natural resources are substantial and yet finite, the country has chosen to place its development on a path defined by a document called Qatar National Vision 2030. According to the government, "By 2030, Qatar aims to be an advanced society capable of sustaining its development and providing a high standard of living for all of its people. Qatar's National Vision defines the long-term outcomes for the country and provides a framework within which national strategies and implementation plans can be developed." The program is defined in terms of four "pillars": Human Development, Social Development, Economic Development, and Environmental Development.

Reaching Upwards
Many of the buildings published in this book are related to the goals of the 2030 scheme. Amongst these, the impressive complex of structures still under development at Education City stands apart, with architects such as Arata Isozaki, Ricardo Legoretta, Rem Koolhaas, and Antoine Predock participating, to name just a few. Having conceived the original master plan of Education City, the Japanese architect Arata Isozaki recently completed the Qatar National Convention Center, which is part of the Education City campus. Its surprising main façade represents the native Sidra tree, symbol of the Qatar Foundation. Her Highness Sheikha Moza bint Nasser, Chairperson of Qatar Foundation, stated, on the occasion of the inauguration of Education City (October 13, 2003), "The Sidra tree, growing strong and proud in the harshest of environments, has been a symbol of perseverance and nourishment across the borders of the Arab world. What is the significance of this glorious tree? With its roots bound in the soil of this world and its branches reaching upwards toward perfection, it is a symbol of solidarity and determination; it reminds us that the goals of this world are not incompatible with the goals of the spirit." Health care has also benefited from considerable investments, with the refurbishment of existing hospitals and the construction of world-class facilities such as the new Sidra Medical and Research Center designed by Cesar Pelli (Pelli Clarke Pelli). An interesting aspect of the ongoing work concerning health care is that good design has been judged to be an essential element in the quality of health care, and that a consistent approach to the entire health care system of the country has been conceived and is being carried out. John Lambert-Smith, Executive Director of Health Facilities Planning and Design at Hamad Medical Corporation states, "There will be a consistency to the aesthetic approach of the patient care environment." The beneficial effects of good design in a hospital environment have been documented, but Qatar is one of the few countries in the world to take such a proactive approach to this area. Good architecture and design, yes, but for a reason.

Breaking the Walls

Culture too has seen investment on a very large scale, in particular with the opening of the Museum of Islamic Art designed by I. M. Pei, and the nearby MIA Park (Pei Partnership) with its outstanding sculpture by Richard Serra. I. M. Pei, who is an American of Chinese origin, sought to create a building that would be in keeping with the region. "It seemed to me that I had to grasp the essence of Islamic architecture," says I. M. Pei. "The difficulty of my task was that Islamic culture is so diverse, ranging from Iberia to Mughal India to the gates of China and beyond. I found what I was looking for in the Mosque of Ahmad Ibn Tulun in Cairo (876–79). The small ablutions fountain surrounded by double arcades on three sides, a slightly later addition to the architecture, is an almost Cubist expression of geometric progression from the octagon to the square and the square to the circle. It is no accident that Le Corbusier learned much from the architecture of the Mediterranean and the architecture of Islam. This severe architecture comes to life in the sun, with its shadows and shades of color." Serra's work for the MIA Park, called *7* is made up of seven 24.4-meter- (80-foot-) high steel plates. It is his tallest sculpture to date and is made with no fewer than 735 tons of steel. Standing out against the background of West Bay, *7* makes it clear that there are no cultural boundaries between East and West in this place. The Museum of Islamic Art and the MIA Park are evidence of not only a strong will to reach for the highest standards in architecture and art, but also of an openness that is a hallmark of the policies that affect the new development of the country. This and other cultural projects are under the control of Qatar Museums, and if the likes of I. M. Pei have indeed sought to create links between cultures in Qatar, it is surely no accident. H.E. Sheikha Al Mayassa states firmly, "People have said, 'Let's build bridges,' and frankly, I want to do more than that. I would like [to] break [down] the walls of ignorance between East and West."

Looking to 2022

Likewise, sports are seeing a massive development now linked to the 2022 FIFA World Cup that will be held in Qatar. Though the first structures related to that event are still in the planning phase, Doha already has facilities at the Aspire Zone that rival those in the most advanced countries. Aspire includes not only the Khalifa International Stadium, but also the Aspire Academy for Sports Excellence, the ASPETAR Qatar Orthopedic and Sports Medicine Hospital, and the even more recent Anti-Doping Lab Qatar, which is accredited by the World Anti-Doping Agency (WADA). The proximity of these facilities is innovative, but perfectly logical, in particular within the overall plans outlined in the 2030 program. Architecture of very high quality is present, but it is clearly placed in the service of ideals and concepts that go beyond the attractiveness or good design of individual buildings or groups of buildings.

Prudence and Patience

The connections between the heritage of Qatar and its rapid modern development are explained in clear terms by the website of Qatar Museums: "Through history, Qatar has always benefited from its geographical location in the Arabian Peninsula and its openness to neighboring countries and civilizations to build its cultural heritage. Therefore, Qatar has been pursuing a . . . policy aimed at preserving and enriching its cultural heritage in such a way as to make it adaptable to the spirit and urges of modernism. . . . After the discovery of oil, the revenues changed Qatar in the space of a generation. Its high standard of living and considerable purchasing power put the country in contact with the consumer world. But at the same the Qataris have kept from the past, from their lives as nomads or fishermen, a kind of prudence, patience, and wisdom."

Though Qatar already has a long history of calling on major international architects, such as Kenzo Tange in the mid 1970's, there has also been a major effort to underline and develop types of architecture that are more closely related to the specific history of the country. A number of examples of this type of realization are published in this volume, including the Souq Waqif (2008), shortlisted for the 2010 Aga Khan Award for Architecture. The Aga Khan Architecture Award report on this project reads in part, "The origins of the Souk Waqif date from the time when Doha was a village and its inhabitants gathered on the banks of the wadi to buy and sell goods. The revitalization project, a unique architectural revival of one of the most important heritage sites in Doha, was based on a thorough study of the history of the market and its buildings, and aimed to reverse the dilapidation of the historic structures and remove inappropriate alterations and additions. The architect attempted to rejuvenate the memory of the place: modern buildings were demolished; metal sheeting on roofs was replaced with traditionally built roofs . . . and traditional strategies to insulate the buildings against extreme heat were reintroduced." Other restoration work on the sites of abandoned or demolished old towns outside of Doha is an ongoing reminder of the commitment of the country to its own past. The Father Emir and the Emir have shown a personal interest in these projects, and the constructive reuse of restored buildings is being actively pursued.

The Real Context
The contents of this book are divided according to the use of the buildings concerned—these are Culture, which includes religious buildings; Government and Health; The Rise of Doha, centered on the development of the urban centers at West Bay and along the Corniche; Education and Sports. Those interested in architecture will find ample material for study, all the more that many of the buildings presented here have not been widely published in the professional press. But again, and finally, the real interest of this book and these projects may be less in viewing them as purely architectural realizations than in seeing them as part of a firm will to make Qatar into a modern country whose resources go beyond oil and gas, toward the importance of heritage, culture, and knowledge in today's world. Those looking for references to Islamic architecture will find examples here, as will persons more familiar with the language of international contemporary architecture. The real story lies deeper, in the use of the buildings, and in the ongoing plan to give Qatar sustainable development and to provide a high standard of living for all of its people. The openness and vision that this implies is the real context of the new architecture of Qatar.

Philip Jodidio
April 2014

Looking up toward
the central oculus of the
Museum of Islamic Art.

Museum of Islamic Art

I. M. Pei, 2008

The Museum of Islamic Art in Doha, Qatar, opened to the public in November 2008.[1] It was designed by the Chinese American architect I. M. Pei. Born in 1917 in Canton (now Guangzhou), China, Pei arrived in the United States in 1935. He received a bachelor of architecture degree from the Massachusetts Institute of Technology (1940), a master's in architecture from Harvard University (1942), as well as a doctorate at Harvard under Walter Gropius (1946). He formed I. M. Pei & Associates in 1955. He won the AIA Gold Medal (1979), the Pritzker Prize (1983), and the Praemium Imperiale (1989). Some of his notable buildings include the John F. Kennedy Library (Boston, Massachusetts, 1965–79); the National Gallery of Art East Building (Washington, D.C., 1968–78); the Bank of China Tower (Hong Kong, China, 1982–89); the Grand Louvre (Paris, France, 1983–93); and the Miho Museum (Shigaraki, Shiga, Japan, 1992–97). Pei was selected to build the Museum of Islamic Art in Doha after an initial competition did not yield a satisfactory result.

I. M. Pei explains, "I was offered a number of sites along the Corniche including the location planned for the earlier project, but I did not accept these options. There were not yet too many buildings nearby, but I feared that in the future, large structures might rise that would overshadow it. I asked if it might not be possible to create my own site. This was very selfish of me of course, but I knew that in Qatar it is not too complicated to create landfill, and thus the Museum of Islamic Art is located on the south side of Doha's Corniche on a man-made island 60 meters (197 feet) from the shore. A new C-shaped peninsula provides protection from the Arabian Gulf on the north and from unsightly industrial buildings on the east."[2] Pei worked on this project with the structural engineer Leslie E. Robertson, with Qatari Engineer & Associates acting as the associate architect. Qatar Petroleum was involved in project management. The building was originally commissioned in October 2000 and was first presented to the Emir in June 2001.

It was decided by His Highness the Emir of Qatar that Doha, in the heart of the lands of Islam, could become a place where some of the finest artworks of the Muslim world could be assembled. Purchases of carpets, glass, ceramics, jewels, and miniatures went forward and continue to this day. It was in this spirit that Pei approached the architecture of the future museum. "This was one of the most difficult jobs I ever undertook," he says. "It seemed to me that I had to grasp the essence of Islamic architecture. The difficulty of my task was that Islamic culture is so diverse, ranging from Iberia to Mughal India to the gates of China and beyond. I found what I was looking for in the Mosque of Ahmad Ibn Tulun in Cairo (876–79). The small ablutions fountain surrounded by double arcades on three sides, a slightly later addition to the architecture, is an almost Cubist expression of geometric progression from the octagon to the square and the square to the circle. It is no accident that Le Corbusier learned much from the architecture of the Mediterranean and the architecture of Islam. This severe architecture comes to life in the sun, with its shadows and shades of color. I had at last found what I came to consider to be the very essence of Islamic architecture in the middle of the mosque of Ibn Tulun."[3]

The central space of the Museum of Islamic Art.

The relationship between the final form of the Doha Museum of Islamic Art and the high-domed *sabil* (ablution fountain) erected in the central courtyard of the Ibn Tulun mosque in the thirteenth century is clear, even if the scale of the Pei building is much larger. "I remained faithful to the inspiration I had found in the Mosque of Ibn Tulun, derived from its austerity and simplicity. It was this essence that I attempted to bring forth in the desert sun of Doha. It is the light of the desert that transforms the architecture into a play on light and shadow. My design has only one major window—it is 45 meters (148 feet) high and faces the Arabian Gulf. I must admit that I have allowed myself another subjective decision, which was based on my feeling that Islamic architecture often comes to life in an explosion of decorative elements. The central space of the museum climaxes in the oculus of an ornate stainless-steel dome that captures patterned light in its multiple facets. A geometric matrix transforms the dome's descent from circle to octagon, to square, and finally to four triangular flaps that angle back at different heights to become the atrium's column supports."[4]

Pei selected the French architect Jean-Michel Wilmotte to design the exhibition galleries, bookshop, and offices. "It was at the request of I. M. Pei that I became involved," explains Wilmotte. "I have known him for quite some time, and I believe that in the context of this complex project, he did not wish to call on architects with whom he had not worked in the past. We have an easy, natural rapport, and that greatly facilitated the process."[5] Wilmotte, working within the architectural forms created by Pei, has made the exhibition galleries into darkened jewel cases, where precious objects from all over the Muslim world are highlighted, usually visible from all sides.

Because it is set on its own man-made island, the Museum of Islamic Art is visible from much of Doha, on the multilane thoroughfares that run along the Corniche, or even in the distance from West Bay. In this sense, it has become a symbol of the cultural possibilities and accomplishments of the State of Qatar. The main entrance to the building is on the south, up a sloping path lined with palm trees that has a cascade in the middle. The visitor entering the museum immediately sees the rear of a sculptural double grand stairway designed specifically to allow a view toward the monumental window described by Pei. The main, or ground, level houses temporary exhibition galleries together with prayer halls for men and women, the museum shop, a 200-seat auditorium, and a fountain café. The window is protected from the sun and dampens sound through the use of a screen of acoustical aluminum rods. Each level of the exhibition floors is spanned by glass bridges that pass above the fountain café, completing a circulation path of the U-shaped balconies cantilevered around the atrium.

True to the original vision of His Highness the Father Emir and his wife, Her Highness Sheikha Moza bint Nasser, who saw the museum as a center of culture and education in the Emirate, the structure includes an education center, reached by walking through a covered passageway that opens onto an arcaded mineral garden with a fountain and central gazebo. A bridge from the exterior also allows visitors to approach the education center directly, without passing through the museum lobby, where upwards of 300,000 visitors have come each year since the opening.

Looking down on the main stairway of the Museum of Islamic Art.

32 The New Architecture of Qatar

Above: The bridge leading to the main entrance of the Museum.

Top: The West Courtyard of the Museum of Islamic Art.

The New Architecture of Qatar 33

Above, left: The Museum seen from the adjacent Museum of Islamic Art Park.

Top: I. M. Pei's pavilion in the West Courtyard of the Museum.

Above, right: With West Bay in the distance, a view from beneath the pavilion.

7, the 24.4-meter- (80-foot-) high sculpture by Richard Serra in the MIA Park.

Museum of Islamic Art Park

Pei Partnership, 2011

The MIA Park, neighboring I. M. Pei's Museum of Islamic Art on the Corniche in Doha, was inaugurated on December 16, 2011, and opened to the public on January 6, 2012. Pei Partnership, the New York firm founded by two sons of I. M. Pei, designed the crescent-shaped park, which has an area of 28 hectares (69 acres). The walkway that borders the small artificial cove next to the museum leads visitors to Richard Serra's first public work of art installed in the Middle East. Her Excellency Sheikha Al Mayassa bint Hamad Al Thani, chairperson of the Qatar Museums Authority (QMA), stated, "MIA Park will be a dynamic place of learning and exploration for children, families, and art enthusiasts, with cultural, educational, and recreational activities designed to attract one and all. We are especially proud that this new destination will feature an extraordinary work by Richard Serra, one of the leading sculptors of our time. Like the Museum of Islamic Art itself, Richard Serra's sculpture will serve as a beacon for the arts in Qatar and will further the QMA's mission to encourage global cultural exchange and introduce the Doha community to art from around the world." The MIA Park includes 5 kilometers (3 miles) of lighted pathways and has already been used for concerts and other events. As visitors approach the outer part of the park, facing the towers of West Bay, they also discover a café and kiosks offering refreshments. These light, tentlike structures designed by Pei Partnership are both discreet and in keeping with the modern art and architecture that they neighbor. There are plans to further develop the park in the future.

Phase one of the park was first discussed between HE Sheikha Al Mayassa, I. M. Pei, Richard Serra, C. C. Pei, and Hiroshi Okamoto (project designer) at a meeting in early December 2008. The project was presented to Sheikha Al Mayassa on February 19, 2010, at the offices of Pei Partnership in New York. Project management was handled by ASTAD. The marine engineers for the project were COWI, Denmark; the structural engineer for the tents was RFR Paris; and landscape design was the work of Michel Desvigne Paysagiste, also from Paris.[6] The structural engineer for the sculpture was Leslie Robertson, who has worked on many of I. M. Pei's projects. Lighting design was by George Sexton and Associates.

Born in San Francisco in 1939, Richard Serra is a noted American sculptor who lives and works in New York. He is best known for his very large, and sometimes controversial, sculptures made from large plates of weathering steel. His work for the MIA Park, called 7, is made up of seven steel plates that are 24.4 meters (80 feet) high, 2.4 meters (8 feet) wide, and 10 centimeters (4 inches) thick. It is his tallest sculpture to date[7] and is made with 735 tons of steel. It offers an unexpected presence not only vis-à-vis Pei's geometric architecture, but also with the astonishing towers of West Bay in the background.

The base of *7* by Richard Serra, with West Bay in the background.

Following spread: One of the kiosks in the MIA Park designed by Pei Partnership.

Serra explains that he is "very interested in Islamic minarets. I studied them from Spain to the Yemen." In this instance, he apparently took his inspiration from the Minaret of Ghanzi in eastern Afghanistan. The minarets erected by the Ghaznavid sultan Mas'ud III (1099–1115) and his son and successor Bahram Shah (1117–1157) are located on a plain to the east of their capital Ghazni. The lower shaft of the Mas'ud III minaret is an eight-sided star in section.[8] "Minarets are round in section," Serra says. "The Ghanzi minaret is the only one that unfolds in a planar manner. And I thought it could dovetail with my own idea for a sculpture."[9] According to the London daily newspaper *The Independent*, "Sheikha Al Mayassa's opinion certainly helped to convince Serra to drop his original design for an eight-sided structure. The move to seven sides was sealed when Serra encountered the history of heptagons, first outlined by Pythagoras as a flat outline. It was the Persian mathematician and astronomer Abu Sahl al-Quhi who created the first seven-sided structure in the tenth century."[10] Serra's sculpture is set on a sculpture plaza that is 76 meters (250 feet) long and 23 meters (75 feet) wide and designed by Hiroshi Okamoto at the outermost extremity of the park. This very elegant base for the work, which takes on the stylized form of a ship's prow, may bring to mind the gray marble pedestal of the *Victory of Samothrace* (Greek, 2nd century B.C.; Musée du Louvre, Paris) that also figures a ship's prow.

There is also a temporary building built by QMA on the grounds of the Museum of Islamic Art called the Al-Riwaq Exhibition Hall, which has already hosted such major events as the 2012 monographic exhibition of the work of the Japanese artist Tadashi Murakami (*Ego*, October 7, 2011–June 24, 2012). It was designed by the Swiss firm Nüssli, an international supplier of temporary structures for events, trade fairs, and exhibitions. The company has been present in Doha since 2006, when it worked on facilities for the Asian Games. In 2008, Nüssli extended Khalifa Stadium by 3,500 seats for the WTA Championship Doha. In December 2010, it completed construction of the Al-Riwaq Exhibition Hall.[11]

The Richard Serra sculpture *7* with West Bay in the distance.

The lecture halls take on unusual forms
in contrast to the main building volume.

Weill Cornell Medical College in Qatar

Arata Isozaki & i-NET, 2003

Arata Isozaki & i-Net, a group that included Makoto Shin Watanabe and Yoko Kinoshita Watanabe (ADH), who had worked with Arata Isozaki on the Los Angeles Museum of Contemporary Art (1986), designed Weill Cornell Medical College in Qatar beginning in October 2001.[12] Her Highness Sheikha Moza bint Nasser, chairperson of Qatar Foundation, and Jeffrey Lehman, eleventh president of Cornell University, formally dedicated the 32,900-square-meter (354,133-square-foot) facility in October 2003. The executive architect for the project was Perkins & Will, and the general contractors were the Darwish Trading Company and Contrack International. Project management involved the Qatar Petroleum Onshore Engineering Department and the Capital Projects Directorate of the Qatar Foundation. Program management was the responsibility of the Tokyo-based firm Fox & Company.

This building is located along the Ceremonial Green Spine conceived by Arata Isozaki as part of his master plan for Education City. It is near the Dukhan Highway and next to Carnegie Mellon University in Qatar (Legorreta+Legorreta) and the new Qatar National Library (OMA / Rem Koolhaas). The program for this facility involves medical teaching as well as research in genetic and molecular medicine and healthcare for women and children. Weill Cornell Medical College in Qatar (WCMC–Q) was established in 2001 as a partnership between Cornell University and Qatar Foundation. It is part of Weill Cornell Medical College in New York City. Premedical teaching began in Doha in 2002 in a wing of Qatar Academy, even before the completion of the new building, making it the first coeducational higher-learning program in Qatar. The medical program was launched in 2004, and the first class graduated in 2008. The biomedical research program was also inaugurated in 2008. WCMC-Q's six-year course of studies leads to a Cornell University M.D. degree. Weill Cornell collaborates in Qatar with the Hamad Medical Corporation, the Sidra Medical & Research Center, and Aspetar Orthopedic and Sports Medicine Hospital as well as the Supreme Council of Health.

Preceding spread: Views of the main façades of Weill Cornell Medical College.

Opposite: Geometric patterns on exterior walls refer to Arab and Islamic architecture.

54 The New Architecture of Qatar

Above, left: Interior common spaces are generous and bright.

Top: A polyhedron-shaped lecture hall, with equilateral triangular faces.

Above, right: The round connecting stairway.

Above: Louvered screens above the entrance to an interior courtyard.

Top: One of the two ovoid lecture halls designed by Arata Isozaki.

The two-story building has twin 200-meter- (656-foot-) long halls that are connected by bridges forming glass-walled enclosures for faculty and student lounges. References to Arab and Islamic architecture include the use of geometric patterns on interior and exterior walls as well as wind towers. Fully 24 meters (79 feet) tall, these towers are reminiscent of the *badgirs* used to cool houses of the region in the past. The building houses classrooms, labs, lecture halls, and faculty offices as well as support and service facilities. A first open courtyard contains two unusual truncated, ovoid lecture halls. Two more lecture halls with unexpected geometric volumes (a dodecahedron, which is a polyhedron with 12 flat faces, and an icosahedron, a regular polyhedron with 20 identical equilateral triangular faces) rise over 16 meters (52 feet) and are placed in a second inner courtyard that also contains three wind towers. Makoto Shin Watanabe explains these forms: "It took a long time, and much effort to settle on the final shapes. We wanted to find a bridge between the notion of a Cornell school and this local culture. We went back to the harmony and geometry in which Islamic science was very strong in the past."

According to Watanabe, the goal of the architects was to capture the feeling of an American medical school located in the Arabian Gulf but designed by Japanese architects, a complex task of synthesis rendered even more difficult by the rapid design-to-completion period of two and half years. The work was facilitated by the detailed program provided by Cornell's architects, Moed, de Armas & Shannon, and by the fact that construction work was carried out six days a week and 24 hours a day. Echoing local designs, the architects created relatively few small windows on exterior surfaces and provided for double walls on the south side. Here, the inner, insulated wall is separated by a one-meter (three-foot) gap from an outer surface of glass fiber reinforced concrete (GFRC or GRC) panels. The roof has aluminum louvers set nearly 5 meters (16 feet) above concrete slabs, allowing space both for air-conditioning equipment and for air to circulate around it. The louvers also filter sun that enters through skylights in the roof. The work of the architects was clearly appreciated by Weill Cornell staff. In 2003, Dr. Carol Storey-Johnson, senior associate dean for education at WCMC-NY, stated, "There's something very airy and uplifting about it [that] has to do with the height of the ceilings, the light that filters through the walls and the glass work, and the artistry and texture of the walls. It's very soothing and calming, and I think very helpful to academic enquiry."[13]

Opposite: A 24-meter- (79-foot-) tall wind tower inspired by the traditional *badgirs*.

Preceding spread: One of the polyhedrons housing a lecture space.

One of the twin 30-meter- (98-foot-) tall translucent light towers that mark the Ceremonial Court.

Ceremonial Court

Arata Isozaki, 2007

The Ceremonial Court is one of the most significant symbolic elements in the master plan for Education City conceived by Arata Isozaki & i-Net.[14] It closes the southern end of the Ceremonial Green Spine that runs in the direction of the National Convention Center (also by Isozaki) to the north. The Ceremonial Court is intended for Education City graduation ceremonies, but also for special events, performances, or concerts, seating up to 3,000 persons. Concerts by Enrique Iglesias (2009), the Vienna Philharmonic (2010), and many others since then have successfully been held in the space. Twin 30-meter- (98-foot-) tall translucent light towers mark the location, but the Ceremonial Court is otherwise essentially horizontal, with a double, precast concrete latticework pergola on the upper level that evokes Islamic decorative designs, albeit in an original and contemporary way. The latticework pattern, which forms the walls and ceiling of the pergolas, casts a variety of complex shadows during the day and glows from within at night. The central stage has a stainless-steel canopy whose unexpected, thin horizontal shapes are visible from a certain distance, appearing almost to float in the sky. Aside from the essentially open space used for ceremonies or concerts, the Ceremonial Court includes a VIP *majilis* viewing area for special guests, with such features as an Egyptian alabaster wall and Italian marble floors. The entire installation is up-to-date, allowing for broadcasts from the site or laser shows, as required. Technical spaces and rooms for performers or personnel are located below the reflecting pool and stage. Designed beginning in April 2004, the largely outdoor 13,000-square-meter (139,931-square-foot) facility was completed in October 2007. The executive architect was KEO International, and the general contractor was Man Enterprise. As was the case for other Education City projects, the Qatar Foundation Capital Projects Directorate together with the Qatar Petroleum Onshore Engineering Department and KEO International assured project management.

The Ceremonial Court is paved with Bethel white granite, and, indeed, white or reflecting surfaces mark the design, giving a kind of unreal shimmer to the surprising forms imagined by Isozaki. Like the great convention center located at the other end of the Ceremonial Green Spine, or even such Isozaki-inspired buildings as the nearby Liberal Arts and Science facility, the Ceremonial Court places an emphasis on horizontality. Its light towers rise in contrast to the overall composition of flat surfaces, but there is a grandeur and a continuity in Isozaki's scheme that make the Ceremonial Court one of his most original and compelling creations. It is true that the Japanese architect is better known for very large, overtly functional structures like the Convention Center, but he proves here that he can imbue a vast space like the Ceremonial Green Spine with significance and meaning. The great, intertwined sidra tree design that forms the facade of the Convention Center quite literally anchors the Ceremonial Green Spine in Qatari tradition. The sidra, the symbol of the Qatar Foundation, is a deeply rooted tree that thrives in the harsh desert conditions of the local climate and geography. Isozaki's two structures can be seen as a metaphorical evocation of the ambitions and reality of Education City. At one end, the long, low Convention Center and its sidra façade represent the deep roots and local traditions of Qatar, while at the other extremity, the Ceremonial Court floats on the desert, looking upward and outward—a kind of symbolic "head in the clouds" that is the point of departure not only for graduating students, but for the future of the country.

Pages 62–65: The light towers and latticework pergolas of the Ceremonial Court.

Opposite: View between the latticework of the parallel pergolas.

High, pointed arches and round chandeliers mark the main prayer hall of the mosque.

Imam Muhammad Ibn Abdul Wahhab Mosque

Private Engineering Office, 2011

The esplanade in front of the Mosque, with a single minaret on the right.

On December 14, 2011, an order was given by His Highness the Father Emir to formally dedicate the largest mosque in Qatar to the scholar and preacher Muhammad Ibn Abdul Wahhab (1703–1792). He inaugurated the new building the next day. Referring to the dedication, the Emiri Diwan stated, "The instructions are in recognition of the outstanding reformer and zealous preacher Sheikh Muhammad Ibn Abdul Wahhab and in reflection of the State of Qatar's intention to revive the Nation's symbols and its cultural values."[15] Muhammad Ibn Abdul Wahhab advocated a strict interpretation of the Quran and the Prophet's words and actions *(hadith)* and is credited with creating the conservative practice of Islam called Wahhabism. It can be noted as well that Sheikh Muhammad Ibn Abdul Wahhab was a member of the Bani Tamim tribe, to which the Emir of Qatar also belongs.[16]

The Private Engineering Office (PEO) supervised construction of this project, originally called the State Mosque, on the order of His Highness the Father Emir, beginning in 2006. The PEO is a government agency of the State of Qatar. Created in 2004 under the auspices of the Emiri Diwan, it receives its directives from the Emir. The Australian firm SMEC handled project management, on-site structural and architectural consultation, construction supervision, and commissioning of all civil, structural, architectural as well as MEP (mechanical, engineering, and plumbing) works. The Doha-based firm Arab Engineering Bureau (AEB) was also involved in project management and interior design.

The mosque has one level below grade containing an ablution area and other facilities. The 12,117-square-meter (130,400-square-foot) ground floor houses the main air-conditioned prayer hall that can accommodate 11,000 men, as well as space for women's ablution. The mezzanine has a women's prayer room with a capacity of 1,200, a library, and two halls, one for men and the other for women, where the Holy Quran can be memorized. Its area is 2,594 square meters (27,921 square feet). The enclosed courtyard in front of the mosque provides space for a further 30,000 worshippers, as required. The development includes an underground electrical substation.

The structure has three main gates and a total of 28 large domes over the central hall and 65 lesser ones above the outer quadrangle that encloses the main internal courtyard. The new building was inspired by the Abu Al Qabib mosque originally built in 1878 in Doha on the order of Sheikh Jassim bin Mohammed Al Thani (1825–1913), the founder of modern Qatar. Sheikh Jassim had seen a similar mosque in Al Zubarah, on the northern coast of Qatar. Al Zubarah is known for its traditional architecture. Village mosques there have an internal courtyard surrounded by high walls, and a minaret with a circular shaft and a simple rounded top,[17] but the mosque he saw in the old fortress there had 21 domes. The sheikh gave the order to build a new mosque in Doha with more than twice as many domes (44). There is thus a relation between the new State Mosque and the austere, domed forms of the recently rebuilt Abu Al-Qabib mosque, located near the Souq Faleh in Doha,[18] designed by the artist Mohamed Ali Abdullah.

That project (see page 283) is an attempt to re-create the 1878 mosque using traditional methods and materials. The artist explains that the Father Emir had the idea of creating a State Mosque to represent Qatar. There was a competition in which he was involved, as was Ibrahim Al Jaidah, amongst others. The concepts that emerged from the competition did not convince the Father Emir. He was thinking of something that was more related to the traditional architecture of Qatar and the region. Mohamed Ali Abdullah was asked at that time if it was possible to use the ideas of Abu Al Qabib mosque on a larger scale. "I did three conceptual paintings, depicting the grand mosque but with the spirit of the Abu Al Qabib mosque," he states. "This type of mosque was actually a very old tradition in the area, and it was about to disappear, but I feel that there is something of its spirit in the new State Mosque."[19]

The single minaret of the new mosque is 65 meters (213 feet) tall. Because of this and its location on a high point of land, the Imam Muhammad Ibn Abdul Wahhab Mosque is visible from a distance from various points in Doha. From its minaret, the towers of West Bay are clearly visible to the south. And yet with its austere coloring and relatively low mass, the relation of this building to local architectural tradition is evident. The entire project has obviously been carried out with an attention to detail and quality. Decorative elements remain relatively discreet, in the habit of Wahhabism. One slightly unusual feature of the architecture is that a parking space for 3,000 cars is provided. Though urban mosques usually are built on the assumption that the faithful will come on foot, here, because of the site, which is bordered by Al Istiqlal, Al Muhandiseen, and Khalifa Streets, car parking was indispensable.

On the occasion of the inauguration of the mosque, His Highness the Father Emir declared, "Our grandfather founder Sheikh Jassim bin Mohammed bin Thani, may God bestow mercy on him, who was a religious scholar and the ruler at the same time, was among those who were receptive of the call of Sheikh Ibn Abdul Wahhab, and who adopted and disseminated his call in our country and abroad throughout the Muslim world. . . .We will spare no effort to continue carrying the message and spreading the tolerant teachings of Islam in the whole world. We see that the *Ummah* is now in need of being renovated and inspired by the resolve and experience of the call of Wahhabism in a way that complies with the current age and its developments."[20]

Opposite: Inside, great attention is paid to the quality of the materials, but overall the design is quite understated.

Detail of façade of the Liberal
Arts & Science Building.

Liberal Arts & Science Building

Arata Isozaki & i-NET, 2004

Officially designed by Arata Isozaki & i-Net, but in fact by Isozaki's younger associates Kazuhiro Kojima and Kazuko Akamatsu (CAt), the Liberal Arts & Sciences building was conceived beginning in January 2001 and completed three years later, as one of the first elements of Isozaki's master plan for Education City.[21] Executive architects for the project were Perkins & Will, while the contractors were Midmac, Contraco and Tradmur Contracting and Trading.

The structure has a floor area of 36,363 square meters (391,408 square feet) divided into two floors above grade and an underground parking lot for 280 cars. Visible near the main entry point of Education City, the building has a unique GRC (or GFRC, glass-fiber-reinforced concrete) panel skin with a pattern based on the quasicrystal structure that was discovered by scientists in the early 1980s. Quasicrystals occurring in nature are ordered but not periodic, thus here a pattern of 30-, 60-, and 90-degree parallelograms appears as the most visible aspect of the façades. The point of origin of the composition that can expand infinitely without repetition is the main entry of the building. In conceptual terms, the pattern was first overlaid on the virtually extended plan and then folded up onto the forms of the building, with the pattern reproduced on each of the façades as well as on the aluminum shades and the reflectors on the skylights.

The two-story building has double walls and a double roof intended as responses to local climatic conditions. The "mosaic" arrangement of internal atria and external courtyards was meant by the architects to evoke patterns found in Islamic cities. Kazuhiro Kojima states, "Here we have noted one of the features of Muslim culture, that their cities are an assembly of 'centers.' Unlike a city of another culture with a solid, symbolic center, a Muslim city encompasses numerous 'centers,' each of which holds different activities. Inspired by those cities, we designed the building to contain many small patios."

The architects sought to actively take into account the different seasons in Doha and their respective temperatures. A system inspired by Middle Eastern wind towers is used to cool the air. The exterior Winter Patios are comfortable in the winter but too hot for use in the summer, and the Summer Patios housing Flexible Learning Areas (FLA) are in air-conditioned atria. According to the architects, the junctions of the FLA spaces have a number of small skylights that bring to mind Hagia Sophia in Istanbul. The architects also used the strong sunlight of Doha as a source of ideas. Glass-fiber gypsum reflectors bring daylight even into spaces where direct exposure to sunlight would not be advisable. Successive louvers and iron shades give the impression that "walking around the building in the overlapping shades, one might feel that he/she is entrapped within limitless veils," says Kojima. The overall plan of the building provides for one in every four facade surfaces to receive sunlight at any given time. Classrooms and the FLA areas are on the ground floor, while teachers' offices and "open resource areas" are located on the upper level. Circular lecture rooms connect the ground and upper levels.

This project was nominated by Ricardo Legorreta and Fumihiko Maki for the 2007 Aga Khan Award, which it did not win; however, the building clearly embodies careful thinking about local climate and culture while conserving a markedly contemporary aspect.

Preceding spread: The full north façade of the building.

Opposite: Shades and garden space echo traditions of the Muslim world.

88 The New Architecture of Qatar

Above: An elaborate geometric pattern related to the façades marks interior surfaces.

The New Architecture of Qatar **89**

Above: Modernity and simplicity are anchored in references to regional building design.

90 The New Architecture of Qatar

The Sidra tree forms visible on the main
façade are also seen in the lobby.

Qatar National Convention Center

Arata Isozaki, 2011

The Qatar National Convention Center (QNCC) by Arata Isozaki is one of the most visible structures of the Education City complex as seen from the north from the Dukhan Highway. It marks one end of the Ceremonial Green Spine conceived by Isozaki as part of his original 2002–4 master plan for the site.[22] His Ceremonial Court is at the southern end of the Green Spine. The 250-meter- (820-foot-) long facade is marked by two symbolic, intertwined sidra trees, which are the symbol of the Qatar Foundation. With their forms calculated by the noted Japanese engineer Matsuro Sasaki and the U.K. engineers Buro Happold, these facade elements, which support the building's exterior canopy, were fabricated in Malaysia and assembled in Doha by the Belgian contractor Victor Buyck Construction.[23] It may be noted that Isozaki's "Florence New Station" competition proposal (2002), also designed with Matsuro Sasaki, had a very similar column form to that seen in the Qatar National Convention Center.[24]

With its nearly 4,000 square meters (43,056 square feet) of solar panels and other energy-conservation features, the convention center was designed to meet the strict LEED Gold Rating standards. Halcrow Yolles/RHWL was the executive architect for Stage 1. Stage 2, the vast exhibition space added at the rear of the original structure, was designed by Burns and McDonnell, while the nearby Car Park Building was the work of WS Atkins and Patrners. Contractors for Stage 1 were Baytur Insaat Tahhut, and for Stage 2, Midmac-Six Construct J.V., with MAN Enterprises fulfilling this role for the car park. The five-story facility, inaugurated in October 2011, includes 40,000 square meters (430,556 square feet) of exhibition space, a conference hall for 4,000 delegates, a 2,300-seat theater, three additional tiered auditoriums, banquet space for up to 10,000 in the exhibition halls, a total of 57 meeting rooms, prefunction, exhibition foyers, luxurious lounges, and hospitality suites as well as dedicated registration desks, a business center, and media rooms. Located on the Dukhan Highway in the northern part of the campus, close to the Qatar Science and Technology Park and not far from the Sidra Medical Center, QNCC has a floor area of about 175,000 square meters (1,884,000 square feet).

One unexpected feature of the Qatar National Convention Center is the presence in the soaring main lobby of a 9-meter- (29.5-foot-) tall bronze sculpture of a spider called *Maman* (1999) by the sculptor Louise Bourgeois. This is a work created by Bourgeois as a part of the Unilever series in 1999 for Tate Modern's Turbine Hall in London. Commenting on the importance of the sculpture to Qatar, Her Excellency Sheikha Al Mayassa Bint Hamad Al Thani, chairperson of the Qatar Museums Authority (QMA), said: "Louise Bourgeois's *Maman* is a true icon of twentieth-century art, an artwork that has captured the attention of millions around the world. We are proud to present this magnificent sculpture at the Qatar National Convention Center. Through displaying various forms of art in public spaces, we aim to inspire local talent and to establish an organic connection between art and the local community." Showing the connection between this kind of initiative and the cultural policies of Qatar, the QMA presented a solo exhibition titled *Louise Bourgeois: Conscious and Unconscious* from January 20 to June 1, 2012, at the QMA Gallery in Katara (DOHA).

Opposite: A night view of the esplanade in front of the main façade.

Preceding spread: Main façade seen from the Dukhan Highway side.

The façade of the building is covered with "butterfly" aluminum elements of different scales.

Doha Tower

Ateliers Jean Nouvel, 2011

Located on the Corniche in West Bay, the Doha Tower is one of the most striking new buildings in Qatar. The noted French architect Jean Nouvel, who has also been called upon to build the Qatar National Museum at the other side of the bay, designed it. Born in 1945 in Fumel, France, Nouvel studied in Bordeaux and then at the École des Beaux-Arts in Paris (1964–72). From 1967 to 1970, he was an assistant of the influential French architects Claude Parent and Paul Virilio. His first widely noticed project was the Institut du Monde Arabe (Paris, 1981–87, with Architecture Studio). He also designed the Quai Branly Museum (Paris, 2001–6) and the Guthrie Theater (Minneapolis, Minnesota, 2006), amongst many other significant projects. Current work includes the new Philharmonic Hall in Paris. Nouvel received the RIBA Gold Medal in 2001 and the 2008 Pritzker Prize.

The new Doha Tower has a relation to two earlier projects by Nouvel. The first of these, the Tour Sans Fins (Paris, 1989), was never built. The 420-meter- (1,378-foot-) tall cylindrical tower was to have risen on a site near the Grande Arche at La Défense, on the axis of the Champs-Elysées in Paris. The base of the cylindrical tower was to have been just 43 meters (141 feet) in diameter. Nouvel's other circular building, the Torre Agbar, was built on the equally symbolic Avenida Diagonal in Barcelona in 2000. At a height of 142 meters (466 feet), the Torre Agbar also has a base diameter of about 45 meters (148 feet). Both of these projects question the largely orthogonal, curtain-walled design of most towers. A circular plan with structural elements arrayed on an exterior ring allow for freer floor plans and views.

The Doha Tower thus has a cylindrical plan measuring 45 meters (148 feet) in diameter. The lightning conductor at the top of the tower reaches a height of 238.1 meters (781.2 feet). There are 41 stories of rental office space with an average floor area in the range of 1,000 square meters (10,764 square feet) per level, with a net office height of 3 meters (9.8 feet) throughout. Each floor provides panoramic views toward the gulf, the bay, the dense urban perspective of West Bay, or even the desert, according to orientation. The total floor area of the tower is 60,000 square meters (645,835 square feet), including three basement-parking levels for 870 cars. The China State Construction Engineering Corporation (CSCEC) was the main contractor. Dar Al Handassa was the construction phase project manager, and Terrell International was the engineer.[25]

Following pages: A view through the geometric pattern of the façade and the tip of the tower.

Opposite: A night view of the building, with lighting by Yann Kersalé.

The client for the Doha Tower is Sheikh Saoud bin Mohammed bin Ali Al Thani. He has his own entrance to the building on the inland side and occupies levels 43 and 44 of the structure, under the dome with a guest house. There is also a restaurant on level 42. The building has an unusual entrance configuration, with a sloping, landscaped ramp leading down to the main entrances that are below grade and covered by a circular canopy. Landscape design is by Jean-Claude Hardy and takes into account the desert climate. As seen from street level, the building in fact appears to have no entrance—it becomes a purely sculptural object on the West Bay skyline, showing no visible surfaces in glass, and with a sunken garden emerging at street level. Visitors entering the generous atrium lobby discover the massive reinforced concrete diagrid columns in an X shape that ring the exterior of the concrete and steel building. The greenery of the sloped gardens also surrounds them. The Doha Tower is nearly in front of the Tornado Tower and not far from the Sheraton Doha.

The building stands out from neighboring towers in good part because of its unusual skin, formed with four "butterfly" aluminum elements of different scales, which are superimposed to create different densities according to orientation vis-à-vis the sun—25 percent toward the north, 40 percent toward the south, and 60 percent on the east and west. Inside, a slightly reflective glass provides further protection, complemented by roller blinds where necessary. This combined system substantially reduces solar gain. The nighttime presence of the Doha Tower is also exceptional because of a computer-controlled LED system designed for the facade by Yann Kersalé. This lighting can be varied in an infinite number of patterns and essentially abstract designs that flow over the building after nightfall.

During the design process, Jean Nouvel stated, "Tall and slim, glittering in its silvery laced silhouette against the skyline, the tower is bound to become a fine landmark on the Doha Corniche." Competing in many ways against a variety of towers in West Bay, some with unusual shapes, some taller, the Doha Tower very much holds its own, confirming the architect's words and offering what might also be termed an iconic presence to the dynamic skyline of the city.

Opposite: A circular canopy covering the main entrance level slightly below grade.

Pages 106–11: Views of the entrance lobby and an office floor.

The New Architecture of Qatar

In the atrium of the Emiri Diwan, looking up at the chandelier, which was handmade in Morocco.

The New Emiri Diwan

Rader Mileto et al., 1972–89

Prior to the construction of the Emiri Diwan, the seat of the Emir and the government of Qatar was Government House, completed in 1969 and now part of the Ministry of Finance. The area concerned has always been of significance for the history and development of Doha and the country. Set on the Corniche, the Emiri Diwan today looks from a slight rise across the water to the towers of West Bay. It is not far from here that the former Emiri Palace, built early in the twentieth century by Sheikh Abdullah bin Qasim Al Thani, was converted into the National Museum in 1972.[26] The first diwan, completed in 1972, was erected on the site of the historic fort of Qal'at al Bida', which was built in the eighteenth century. In 1801 it was described as the *husn* (fort) by David Seton, the British Resident in Muscat.[27] Florian Wiedemann writes that to the "west the Grand Mosque (Masjid al Shuyukh, 1965) and the Clock Tower (1956) . . . complete a modern architectural ensemble intended to represent Qatar's independence as well as indicate a clear cut with Doha's historic style of building."[28]

The old Emiri Diwan is a two-story building with two courtyards partially ringed with offices on the first floor. State function rooms such as a *majlis* and a dining room were located on the ground floor. Salma Samar Damluji, who authored the only well-illustrated publication to have appeared thus far on the Emiri Diwan, writes that the palace "said to have been designed by a Yugoslav engineer, was characterized by the use of a flattened, Mogul-inspired arch motif, symbolic of Islamic heritage and reflecting Qatar's historically close trading links with India, but not indigenous to Gulf architecture."[29] The ogee arches employed for the Emiri Diwan were of course widely used not only in both Hindu and Moghul architecture but also in European Gothic architecture, for example. The main, ceremonial entrance of the building does not face the bay, as might have been expected, but rather the east, the Clock Tower, and the Souq Waqif beyond. Recently renovated under the authority of the Private Engineering Office (PEO), the 1972 building is notable for its generous interior spaces and decor that might be considered relatively sober, given its use for official functions. Furnishings and such details as marble or plasterwork have been carried out in good part by Italian firms.[30]

By the mid-1970s this structure was already judged too small for its official functions. A design for an enlargement was developed by Kenzo Tange as part of his 1976 competition-winning scheme for the Qatar Government Center, which was to have been located on the Corniche and to have also included a courthouse and a National Assembly building, as well as associated structures. In part because it was considered too close to the Corniche, Tange's modern scheme was not executed, with the exception of the Ministry of Finance, which encompassed the former Government House building and was completed in 1984.

Opposite: A view from an octagonal courtyard toward the Corniche.

Preceding spread: The main entrance and south façade of the Emiri Diwan.

A new program for the enlargement was subsequently elaborated by the Technical Office of the Diwan. Under the supervision of the office's director, Hisham Qaddumi, a simple scheme was produced, proposing a three-sided layout that would accommodate the offices of the Emir, the Crown Prince (heir apparent), and the Prime Minister.[31] It was on this basis that an architectural plan was drawn up by the Italian architects Rader Mileto and Batori. Rader Mileto was the architect of such projects as a private residence for the imperial court of Iran (Kish, 1972) and the Sheraton Hotel on the Creek (Dubai, 1978). Construction of the new Emiri Diwan began in 1983. It was "contracted out as a number of design-build packages in order to obtain both the character and quality of work envisaged by the client. Each of the packages were based on client-initiated design briefs which were seen to be a necessary method of directing the design of a building whose external presence would represent the face of Qatar both to those living in the country as well as to foreign dignitaries visiting the country. Its interior, in particular, would need to reflect this."[32]

The plan of the new Diwan, completed in 1989, is symmetrical and U shaped, with the courtyard opening on the south side of the building, which is to say away from the Corniche and West Bay. The southern gateway faces the Al Rayyan Road, with the new Msheireb complex on the opposite side of the avenue. Salma Samar Damluji writes, "The reorientation of the new Diwan towards the south and west, in contrast to the eastward-facing portico of the older Diwan building, created a renewed sense of engagement between the seat of government and the areas of the city that were expanding in these directions. Whereas the south and east entrance gates of the old Diwan looked out over the Clock tower and Corniche towards the sea, that of the new Diwan delineated a state-entrance approach from the heart of the city."[33] The newer Diwan building is centered on a large atrium and grand entrance. High-quality precast concrete was used to form the exterior of the structure, which evokes the tradition of fortified buildings on or near this site, as well as indigenous decorative patterns. The British planner John Lockerbie, who was head of planning in Qatar through much of the 1970s and 1980s, writes, "This is not pastiche but is an honest attempt to re-create the form of Qatari buildings, introducing modern methods of construction to deal with the much greater scale of the new architecture."[34]

The Italian designer Bruno Fiorentino (Fiorentino Form) worked on the interiors to "infuse the design with an authentic Qatari aesthetic, using many traditional patterns executed in traditional and modern materials."[35] A careful study of traditional decorative patterns, largely as seen in the Gulf and Qatar itself, was the basis for much of the interior design of floors, ceilings, doors, and furniture. Despite the large scale of the enterprise, these details were hand carved by local and foreign craftspeople. The private offices of the Emir, Crown Prince, and Prime Minister are located on the first floor of the building. The top floor provides access to an open roof terrace. A state banquet hall to the west and people's *majlis* to the east of the main entrance and central atrium are located on the ground floor. Salma Samar Damluji concludes, "The building mass, architectural vocabulary and patterns that distinguish the setting for all [its activities] express the same modern fusion of Western design and new materials with Arab and Islamic skills, culture and ideas that also lies at the heart of Qatari government and culture."[36]

Pages 120–22: Views of the central atrium of the Emiri Diwan.

Opposite: The carved teak entrance doors of the Emiri Diwan.

126 The New Architecture of Qatar

Under the curving roof
of the main terminal.

Hamad International Airport

Bechtel, HOK, ADPI, et al., 2012

Hamad International Airport was conceived to replace the existing facility located just four kilometers (2.5 miles) away, near the southern end of the Corniche. Phase one of the project offers capacity for 24 million passengers per year on a 22-square-kilometer (8.5-square-mile) site, much of which is land reclaimed from the sea in the largest landfill operation conducted in the Arabian Gulf. It is one of the ten largest airports in the world by area.[37] Planned passenger capacity was doubled from 12 million in 2005 to accommodate the ongoing success of Qatar Airways. Ultimately, capacity is due to rise to 48 million passengers per year by 2018. The first phase of airport planning and design was awarded to the U.S.-based Bechtel Group early in 2004.[38]

The project started in early 2004 with a detailed planning and design phase, when Bechtel produced a master plan of the new airport. Working with Bechtel as of 2004, the San Francisco office of HOK, led by Ali Moghaddasi, senior vice president and director of design for the company's aviation group, was given responsibility for the architecture, engineering, and landscape architecture of the main passenger terminal, a parking structure, a mosque, central utility plant, and other site improvements. The size of the terminal is approximately 600,000 square meters (6,458,346 square feet), making it the largest building in Doha.[39] HOK has worked on more than 50 airport terminals worldwide, including the King Khaled International Airport terminal complex in Riyadh, Saudi Arabia.[40]

The airport has two parallel runways, one 4,850 meters (15,912 feet) long and the other 4,250 meters (13,944 feet) in length, capable of handling a fully loaded Airbus A380. Hamad International Airport was one of the first major airports conceived to be able to receive the A380. The most architecturally remarkable structure on the site is the main terminal, with its overhanging wavelike roof sheltering an inward-angled glazed façade to reduce solar gain on the main entrance side. Made with "moly-grade lean duplex" stainless steel, it is apparently the largest stainless steel roof in the world.[41]

Placed perpendicular to the runways, the terminal creates an impressive and generous impression from the point of entry on. After checking in, passengers are led to the 14,000-square-meter (150,700-square-foot) central commercial area containing retail, food and beverage, and other passenger amenities. In keeping with the reputation that Qatar Airways has established, there are dedicated areas for the national carrier, including numerous lounges for business and first-class passengers as well as VIP lounges designed by renowned interior designer Antonio Citterio of Italy. There are 41 contact gates and 23 remote gates. Within the complex, there is a 100-room transit hotel and a purpose-designed automated people-mover created by DCC Doppelmayr Cable Car from Wolfurt, Austria. This 500-meter- (1,640-foot-) long Cable Liner Shuttle links the terminal building with the gates at a rate of 6,000 persons per hour.[42] It is planned to increase the main terminal in size to as much as 900,000 square meters (9,687,520 square feet) as phase three of the airport plan advances. The Terminal Building was built by Sky Oryx Joint Venture, which is made up of the Taisei Corporation from Japan and TAV Construction from Turkey.

Opposite: Gardens to the rear of the main terminal.

Preceding spread: A night view looking from the Emiri Terminal to the main terminal.

Above: Main terminal departures concourse.

Above: Main hall for departures.

Top: Main terminal departures concourse and check-in gates.

Al Maha Lounge	صالة الماها ←	بوابات Gates CDE ↑	Gold Lounge	الصالة الذهبية ↑
Silver Lounge	الصالة الفضية ←	Toilets → دورات مياه	Oryx Lounge	صالة الأوريكس ↑
Currency Exchange	صرافة →		Hotel & Spa	فندق ومنتجع ↑

HOK also designed the airport mosque, which is located in the central axis of the terminal, opposite the entrance. The unusual structure, in a "waterdrop" configuration, is circular in plan and clad in glass. The 2,000-square-meter (21,528-square-foot) mosque is 47 meters (154 feet) in diameter and faces a reflecting pool and plaza. Hamad International Airport has 40,000 square meters (430,556 square feet) of landscaped zones on the site. The In-Flight and Commercial Catering Center, a 65,000-square-meter (699,654-square-foot), three-story structure designed to prepare 70,000 meals a day for Qatar Airways and twenty-five other international airlines, was designed by Ali Moghaddasi and his team at HOK, with systems and kitchen automation by the German firm I+O.[43]

A number of outstanding structures at Hamad International Airport were designed by firms other than HOK. Aéroports de Paris International (ADPI) was responsible for the main control tower, whose body assumes the form of "an extruded triangle truncated by a virtual cylinder." It is 90 meters (295 feet) tall and has an LED system that makes "an illuminated crescent moon" appear on the glazing at night. ADPI was also in charge of the new Emiri Terminal, a 12,000-square-meter (129,167-square-foot), two-story structure with official reception rooms for heads of state, apartments for the Emir, ministers' rooms, a VIP departure and arrival lounge, as well as facilities for the Emir's guards and other attendants. Distinguished arriving visitors can disembark directly from their plane on the ceremonial podium in front of the Emiri Terminal. The terminal, built by a joint venture of the Japanese firm Takenaka and local firm CDC, stands apart from the public facilities of the airport and is "made up of layers of longitudinally curved walls with triangular sections, the exterior walls are reminiscent of high nautical sails."[44] It also stands out because of the great attention paid to the quality of the materials and decorative elements employed, particularly in the interiors. ADPI also provided concept design services for the Qatar Aviation Services Cargo Terminal, Qatar Airways Aircraft Maintenance Facility, and Emiri Hangars A and B.

Aside from HOK and ADPI, other firms were involved in the design and other visible aspects of facilities that are part of the project. The Dearborn, Michigan, firm Ghafari Associates participated in the design development of the 50,000-square-meter (538,196-square-foot) Qatar Aviation Services Cargo Terminal and the 150,000-square-meter (1,614,587-square-foot) Qatar Airways Aircraft Maintenance Facility, a fully air-conditioned hangar that can accommodate eight wide-bodied aircraft (including two A380s) or various combinations of aircraft up to a maximum of thirteen simultaneously. Ghafari also worked on the design development of the In-Flight and Commercial Catering Center. Ghafari participated in the design development of Emiri Hangar A, an 18,000-square-meter (193,750-square-foot) structure that can accommodate up to three A340-600s simultaneously, and Emiri Hangar B, which includes 1,000 square meters (10,764 square feet) of offices and shops and an 11,300-square-meter (121,632-square-foot) hangar that can accommodate up to four A321s simultaneously.[45]

Pages 134–39: The Mosque at Hamad International Airport and the Emiri Terminal.

Opposite: Entrance of the Emiri Terminal.

The Aspire Tower
by Hadi Simaan.

Aspire Zone

*GHD, Cox, PTW, Hadi Simaan,
Roger Taillebert, et al., 2005*

The Aspire Zone is a 240-hectare (593-acre) site essentially dedicated to sports. Located 8 kilometers (5 miles) from the central business district of Doha, its facilities include Khalifa International Stadium and the Aspire Dome. These structures and others including the Aspire Tower and ASPETAR were developed after 2000, when Doha was granted the right to host the fifteenth Asian Games (December 1–15, 2006). The master plan was drawn up in 2003 by GHD Consortium, which involved two other large Australian architecture and planning firms, Cox Architecture and PTW. Three pivotal buildings were identified for the work, with Khalifa Stadium being the most significant. GHD, Cox, and PTW were also commissioned to design the stadium redevelopment, upgrading the open-air football stadium built in 1976 from 20,000 seats to a partially covered 50,000-seat venue.[46] A 265-meter (869-foot) arch marks the eastern side of the stadium and makes it visible from a considerable distance in the flat outskirts of Doha. This arch was used as a platform for the fireworks marking the 2006 Asian Games. Arup Sydney was also involved in the project, in particular for the lighting arch and the main roof, which is made up of 15,000 square meters (161,459 square feet) of lightweight PTFE-coated membrane spanning about 220 meters (722 feet) along the length of the stadium, with a width of 50 meters (164 feet). The roof membrane is supported on a cable net structure tensioned against two arches at the rear of the seating.[47]

Since reopening on June 4, 2005, aside from the 2006 Asian Games, Khalifa International Stadium has hosted two international-friendly football matches, between Brazil and England on November 14, 2009, and Brazil and Argentina on November 17, 2010, as well as the athletics of the 2009 ISF World School Games, held December 8–12, 2009. More recently the final of the 2011 AFT Asian Cup was held there, as were the 2011 Pan Arab Games. Plans for the 2022 FIFA World Cup, which will be held in Qatar, call for Khalifa International Stadium to be further upgraded to host quarterfinal and semifinal matches, with a new seating capacity of approximately 62,000.[48]

The Aspire Academy for Sports Excellence was established by Emiri Decree No. 16 of 2004 as an independent government-funded agency. Later, Emiri Decree No. 1 of 2008 incorporated the Aspire Academy as a strategic business unit (SBU) into the new, parent organization, the Aspire Zone Foundation. The Aspire Dome, part of the home of the Aspire Academy, was inaugurated by the Emir on November 17, 2005.[49]

Preceding pages: The Aspire Tower seen from the exterior and inside.

Opposite: The nineteenth-floor cantilevered swimming pool at the Torch Hotel in the Aspire Tower.

148 The New Architecture of Qatar

Above: A closer view of the Dome showing its split design.

Top: The Aspire Dome in its context.

Above: A side view of the Dome, designed by Roger Taillibert.

Top: The track and sports facilities in the Aspire Dome.

The Aspire Dome and Academy were designed by the noted French architect Roger Taillibert in collaboration with CICO. Born in 1926, Taillibert was the architect of the Parc des Princes stadium in Paris (1972) and the Olympic Stadium in Montreal (1976). Beginning in 2002, Taillibert was asked to assist in the development of what was then called Khalifa Sport City. His original scheme included the redesign of Khalifa Stadium but finally focused on the Aspire Dome and the Aspire Academy.[50] The main contractor for Taillibert's Aspire project was Consolidated Contractors Int. Co./Murray & Roberts, and it was completed in September 2005. The site of Taillibert's project measures a total of 1,624,000 square meters (17,480,591 square feet), with 290,000 square meters (3,121,543 square feet) in built area. The freestanding, 46-meter- (151-foot-) high dome houses a football stadium, a track-and-field arena (including a 200-meter track), a swimming stadium, 8 fencing *pistes*, 2 sports halls, 3 martial arts arenas, 13 table tennis courts, and 2 squash courts within the two hemispheres of its 250-meter (820-foot) span. There is space for up to 15,000 spectators within the various halls.[51] The steel structure was erected in just two years. The execution of the roof design was handled by the Arabian Profile Company Limited (APL). The roof is covered with 85,000 square meters (914,932 square feet) of blue and anodic silver aluminum composite panels. At the time of its opening, this was the largest multipurpose sports dome in the world.

Also part of the Aspire complex, the Hamad Aquatic Center occupies five floors and contains two Olympic swimming pools, two Olympic diving pools, a warm-up pool, and main pool seating for 3,000 persons. An upgrade of an existing facility handled by Dar Al-Handasah Shair and Partners/Projacs, working with Al Jaber Trading and Contracting, was completed in 2006 after an 18-month construction period.[52]

Together with these sports facilities, the associated ASPETAR sports and orthopedic hospital, the iconic Aspire Tower, and the nearby Anti-Doping Lab, as well as a large shopping center called Villagio, the Aspire Zone, located within easy transport distance from the center of Doha, is one of the most remarkable and well-designed sports complexes in the world.

Opposite: A 265-meter (869-foot) arch marks the eastern side of Khalifa Stadium.

Preceding pages: The exterior and interior of the conical glass tower that marks the entrance to the Aspire Dome.

The covered arena at the
Al Shaqab equestrian facility.

Al Shaqab

Leigh & Orange, 2011

Above: The open arena at Al Shaqab.

The New Architecture of Qatar **159**

Above, left: The covered arena.

Top: Another view of the open arena.

Above, right: A structural detail of the building.

Al Shaqab Academy is a world-class equestrian facility featuring state-of-the-art installations for the care and competition of some of the fine horses belonging to His Highness the Emir of Qatar, amongst others.[53] It is located south of the campus areas of Education City outside of Doha. The architect selected for this project was Leigh & Orange, a well-established international design firm founded in Hong Kong in 1874. Leigh & Orange also designed Al Janadriyah Racecourse (Riyadh, Saudi Arabia), a complete new racecourse with a dirt track, grandstand for 3,000 persons, and stabling for 1,400 horses; the HKJC Shatin Racecourse (Shatin, Hong Kong), an international racecourse built on 81 hectares (200 acres) of reclaimed land that has three tracks, associated stabling and training facilities for 1,300 thoroughbreds, and grandstands to accommodate 32,000 people; as well as the 2010 Asian Game Equestrian Venue (Guangzhou Conghua, China). Leigh & Orange was the design and executive architect for Al Shaqab Academy, with Leighton Contracting (Qatar) WLL as the contractor. The stables and arena were completed in April 2010, and the remainder of the facility in 2011. Qatar Petroleum and KEO International acted with the Qatar Foundation Capital Projects Directorate as project managers. The interests of Al Shaqab also lie in its ties to the history of Qatar. The Rayyan area, where Education City is located, was the site of the battle of Al Shaqab, or Al Wajba, in which the Qataris, led by Sheikh Jassim bin Mohammed Al Thani (1825–1913), defeated the Ottomans. This historic event led to Qatar's independence.[54] The former Ottoman stables, recently restored, are on the grounds of Al Shaqab, emphasizing the link between this aspect of Qatari history and the contemporary equine facility.

A dramatic 400-meter (1,312-foot) "clamshell" roof unifies the composition and encompasses two competition arenas as well as a grandstand for 7,200 spectators and a warm-up arena for the competitors. The grandstand faces both the indoor and outdoor arenas and has carefully designed facilities for heads of state, VIPs, public, and media as well as the competitors and judges. The overall plan for the vast site, which measures 980,000 square meters (10,548,632 square feet), assumes the shape of a horseshoe. The project was a finalist in the World Architecture Federation Awards for best stadia facility and a semifinalist in the World Architecture News best civic building category. It was also been awarded the Arab Investment Summit Architectural Award for best interior. The complex includes an Administration and Maintenance Compound, dressage stables, Emiri stables, an equestrian club, the arenas, a riding academy, show-jumping stables, a veterinary care area, and numerous other facilities including a swimming pool expressly designed for horses.[55]

Opposite: Al Shaqab was winner of the 2012 Grand Award, Quality Building Awards (Hong Kong).

A curving perforated stainless-steel veil
covers the buildings of the complex.

Qatar Science & Technology Park

Woods Bagot, 2010

The Qatar Science and Technology Park (QSTP), located on the northern side of the Dukhan Highway not far from the rear of the National Convention Center, is intended to provide accommodation, services, and support for organizations whose predominant activities include research, product or process development and technology-related training.[56] In practice, emphasis is put on such areas as energy, which is of course central to the economy of Qatar. The nonprofit organization benefits from a special economic status intended to encourage the participation of leading corporations. QSTP is considered nothing less than an integral part of Qatar's National Vision 2030, which aims, through sustainable development, to transform Qatar into one of the world's most advanced economies by 2030. This is to say that it is an interesting complement to the educational and scientific community that forms the major part of the installations of Education City. Qatar Foundation and QSTP have twenty-one partners who participated in the development of the complex.

The 170,000-square-meter (1,830,000-square-foot) main buildings of the Qatar Science and Technology Park, designed by the old Australian firm Woods Bagot (founded in 1869), were completed in 2009 and inaugurated on March 16 of that year. Burns & McDonnell, from the United States, designed the 25,000-square-meter (269,000-square-foot) GEATRC building, which was completed in 2010. Contractors for the main facility were Darwish Trading and Contrack. Geoson Construction Dynamics was the contractor for the GEATRC. The Qatar Foundation Capital Projects Directorate, Qatar Petroleum Onshore Engineering Department, and KEO International handled project management in both instances.

The complex is set on a podium that contains parking for 1,500 cars. This feature ensures that the main entrance level of the buildings is free of automobile traffic, encouraging more interaction among users. Above the podium, the facility is made up of two buildings intended for high-technology research and an Incubator building (Emerging Technology Center) intended for startup companies. The most visible feature of the buildings from the exterior is a generous perforated stainless-steel veil that covers the structures and provides shade. The waveform of this stainless-steel canopy sits above buildings that are essentially rectilinear. The 27-meter- (89-foot-) clear span of floor spaces in the technology buildings was designed to accommodate any kind of laboratory or research installation. The Woods Bagot structure was the 2009 international category winner of the Australian Institute of Architects National Awards. As they state, "The architectural aesthetic is striking and contemporary, whilst respectful of the Qatari culture and designed for the desert climate."[57] Woods Bagot is also the architect of the College of the North Atlantic Qatar (Doha, 2005). Clients of the QSTP include Chevron, Cisco, ConocoPhillips, ExxonMobil, Microsoft, Tata, and Shell.

The GEATRIC building (General Electric Advanced Technology Research Center) has four levels, including a dedicated parking area, and accommodates spaces for several of GE's departments, with an emphasis on the Aviation division, which has tall space for aircraft engine research and disassembly.

Following spread: The stainless-steel veil links the Information Center to the Tech and GE ATRC buildings.

Opposite: Interior circulation spaces are airy and inviting throughout much of the complex.

168　The New Architecture of Qatar

Above, left: Outdoor covered plaza near the Information Center.

Top: The Information Center and its wing-like canopies that extend to the other buildings.

Above, right: A detail of the façade design.

The New Architecture of Qatar 169

Above: The soaring stainless-steel canopy and a bright café space.

Top: A bright café space.

Following pages: An interior image with a view of a glass ceiling (left).

172 The New Architecture of Qatar

The Tornado Tower with its curving diamond-shaped rib design.

Tornado Tower

JKS SIAT International, CICO
Consulting Architects & Engineers, 2009

The Tornado Tower stands out in its West Bay setting. *Opposite:* The esplanade at the Tower's base.

Designed by the German firm JSK SIAT International and the Qatari firm CICO Consulting Architects & Engineers, the Tornado Tower is one of the most visible buildings in the rising West Bay area of Doha. At 52 stories and 200 meters (656 feet) in height, it stands out during the day but also at night, with its 35,000 individually controllable LEDs arranged on the entire façade. The building, whose lead architect was Robinson Pourroy from SIAT, has a round floor plan, with a rhomboid shape in section that contributes to the "tornado" image implied in its name. The project contractor was Midmac-Six Construct JV. The available floor area of up to 2,000 square meters (21,528 square feet) per level varies because of the external form of the tower. The designers explain, "The shape is based on a construction optimized for economic and energy efficiency that can withstand heavy loads despite its own light weight, while featuring an extremely flexible interior completely free of interior supports. Steel-reinforced concrete slabs combine the characteristic steel support structure and the inner reinforced concrete core in the 'eye of a tornado.' A lighting concept devised with Frankfurt lighting artist Thomas Emde emphasizes the hyperbolic design of the tower's structure, with individually controlled lighting elements where the grid members join."[58] The lighting system can even be used to create patterns on the building that resemble a swirling tornado. The client for the Tornado Tower, which is located close to Jean Nouvel's Doha Tower, is Qatar Investment Projects and Development Holding Company (QIPCO), and the gross area of the building is 80,000 square meters (861,113 square feet). The site area, quite generous in terms of free space at ground level, is 11,500 square meters (123,785 square feet). Parking areas for 1,700 cars and other spaces below grade amount to 55,000 square meters (592,015 square feet) in area.

Construction was completed in December 2008, and the building began to be occupied as of June 2009 by such prestigious clients as the Qatar Foundation. The building features a special floor-to-ceiling Ipasol solar control glazing that gives the structure a bluish color in daylight. The trapezoidal window units were assembled in aluminum frames and installed using floor cranes. Different panel sizes were required for each floor, but the system employed did not require the use of curved glass. The panels support the external steel lattice that accentuates the form of the building and is used for the lighting effects.[59]

The architect Ahmad Cheikha (CICO) explains, "Inspired by the local swirling sand column phenomena, the Tornado Tower uses an axonometric diagrid of structural steel as the principal structural element with radial steel beams from the central reinforced concrete core to the diagrid support the composite floor plates, thereby obviating internal columns resulting in a clear and unobstructed office floor space at each level."[60] The Tornado Tower received the 2009 Council for Tall Buildings and Urban Habitat (CTBUH) award for best tall building in the Middle East and Africa, the first structure in Qatar to receive this type of honor.[61]

Following spread: Interior design is informed by the circular floor plan of the structure.

Opposite: The powerful form of the rib structure of the Tower is visible at every level.

178 The New Architecture of Qatar

The New Architecture of Qatar

The exterior amphitheater facing the waters of the bay of Doha.

Katara Cultural Village

Cansult Maunsell, 2010

Traditional pigeon houses near the main entrance. *Opposite:* The main entry door of the amphitheater.

The creation of the Katara Cultural Village was announced in December 2008, shortly after the inauguration of I. M. Pei's Museum of Islamic Art.[62] The name for the project is derived from Catara, the most ancient (ca. 150 A.D.) identification for the Qatar Peninsula.[63] The Cultural Village is located near West Bay, in the diplomatic precinct, and encompasses conference and exhibition areas, indoor and open-air theaters, a mosque, an opera house, leisure facilities, and traditional cafés and restaurants. The design includes tall pigeon houses that greet visitors near the main entrance and a grand outdoor amphitheater facing the sea.

Katara is laid out like an old town or souk, leading to a beachside sequence that groups restaurants and the amphitheater. A private beach features cabanas and water sports activities. Today, Katara houses the headquarters of the Qatari Society for Engineers, Qatar Fine Arts Society, Qatar Museums Authority Gallery, Katara Art Center, Qatar Photographic Society, Childhood Cultural Center, Theatre Society, and Qatar Music Academy. Also present are the Gannas Association, dedicated to the promotion of traditional Arab hunting, and the Doha Film Institute.

The ambition of this program is clearly stated: "In line with the goals set forward by the Qatar National Vision 2030, Katara serves as a guardian to the heritage and traditions of Qatar and endeavors to spread awareness about the importance of every culture and civilization and as such, Katara hosts international, regional and local festivals, workshops, performances and exhibitions."[64] The Opera House is the venue where most of the concerts of the Qatar Philharmonic Orchestra (QPO) are held.[65]

The master planning, design, and construction management and supervision of Katara is the work of Cansult Maunsell, a division of AECOM. Cansult Maunsell designed a total of forty buildings for the complex as well as its amphitheater. The site has assumed the form of large sand dunes, made with imported fill, with the goal of creating a "traditional hillside community theme."[66] The site of Katara measures 99 hectares (245 acres) of reclaimed coastal land and is currently the object of a residential development involving the design of 235 villas, a project undertaken by GHD. Managed by the government of the State of Qatar, GHD is involved in urban design, planning, infrastructure, and landscaping for this project.[67]

In architectural terms, Katara is clearly something of a mixture of different styles, putting an emphasis on Qatari heritage. The amphitheater, with its white marble surfaces, might bring to mind more Mediterranean architecture, for example. Ibrahim al-Ali, a Qatari engineer who worked on the Katara project, describes the village as "the outcome of a cultural and architectural vision that sought inspiration from Arab and international cultures and merged them with Qatari heritage to create an architecture and a design that combine several cultures in one place.... We strived to combine what some would call a contrast of styles. We combined ancient and contemporary architecture as well as the architecture of civilizations that erased the civilizations that preceded them."[68]

Following pages: The architectural design is based on regional traditions but still maintains an air of modernity.

Opposite: Internal passageways are shaded and benefit from the sea breeze.

SECTIONS - قسم
< F,E
A ⌄

The Sheraton Hotel with the upper part of Jean Nouvel's Doha Tower visible to the right of the image.

Sheraton Doha Hotel

William Pereira, 1982

Subsequent to the independence of the State of Qatar, declared on September 3, 1971, schemes to develop Doha were launched. The planning company Llewelyn-Davies, Weeks, Forestier-Walker & Bor was invited to send a team to begin the planning process in the early 1970s.[69] They were the first to propose dredging the northern part of Doha Bay, where the New District of Doha (NDOD) would develop. Reclamation work for NDOD began in 1974, and William L. Pereira Associates was called on to elaborate on the plans in 1975, producing its first concept plan the same year. Planning, design, and execution of the New District of Doha were carried out under the direction of the technical office of the Emiri Diwan.[70] Elements in the plan included Qatar University, diplomatic and ministry areas, and a 500-bed hotel and conference center, as well as a central business district. By 1981, the West Bay area had been largely dredged and cleared. The land reclamation reshaped Doha Bay into a crescent with a five-star hotel at its northern tip.

The American architect William L. Pereira (1901–1985) is best known for his iconic Transamerica Pyramid (San Francisco, 1972), but he was also a designer of Los Angeles International Airport (Pereira & Luckman, 1958). The first structure completed in the New District of Doha was the iconic Sheraton Hotel and Conference Center, designed by C. Y. Lee of William L. Pereira Associates and built by the Engineering Services department of the Ministry of Public Works.[71] Gerhard Foltin, the first general manager of the hotel recalls, "I came to Doha on June 30, 1977 . . . I remember that when I got to the construction site, I saw nothing but drawings of the hotel. The surrounding areas and roads had no buildings or other forms of construction." Describing the construction process that he witnessed, Foltin continues, "three thousand steel columns were installed as submerged foundations for the hotel. This technique proved to be effective; during the past 25 years the hotel has not exhibited any fissures or cracks."[72] Aerial photographs of the district from the early 1980s show the form of the Sheraton rising nearly alone on its point of land in the bay.

The 16-story Sheraton Hotel and Conference Center consists of two three-sided truncated pyramids that come together around a central column and at the first-story lobby and restaurant area. The hotel is topped by an additional level that is angled out from the rest of the building, reaching a total height of 57 meters (187 feet). The steel frame structure with white, precast concrete cladding was designed to withstand winds of 160 kilometers (100 miles) per hour and cost $150 million to build. Erected on 40 hectares (99 acres) of landfill at the northern end of the bay, the Sheraton Doha was inaugurated on February 22, 1982, the tenth anniversary of the accession of Sheikh Khalifa bin Hamad Al Thani as Emir of Qatar. The Sheraton is still an iconic presence in the city. It features a 13-story atrium served by five glass-enclosed elevators and surrounded by guest rooms. A ballroom for 700 persons and the conference center with capacity for 650 are also part of the original project.[73] The hotel currently has 371 rooms and 64 suites.[74] A refurbishment of the hotel was announced in 2011, to be carried out over a two-year period. This was one of the first structurally innovative contemporary buildings to be erected in Qatar, and the first large international hotel in Doha. It gave a forward-looking image to Doha at a time when the city was just beginning its rapid development.

Following spread: An "aerial" view taken from a nearby tower of the Sheraton Hotel at the tip of the Corniche.

Opposite: Looking up into the atrium of the Sheraton Hotel.

Sculptural elements designed by
the architects mark the entrance
area of the Student Center.

Student Center

Legorreta+Legorreta, 2010

The fourth building on the Education City campus designed by Legorreta+Legorreta provides a "home away from home" for an estimated 10,000 Education City students, with an environment intended to promote social and cultural interaction.[75] The multifunctional building offers help to students in areas such as healthcare, student counseling, financial aid, and housing as well as recreational spaces and ambitious complementary programs relating to culture and sports.[76] The executive architect for the project was Langdon Wilson International, and the contractor was Tadmur. The usual team formed by the Capital Directorate, Qatar Petroleum Onshore Engineering Department, and KEO International Consultants controlled project management.

Located near the campus core on the southern side of the Dukhan Highway, the building will neighbor the future Oxygen Park. The 39,700-square-meter (427,327-square-foot) facility is laid out on two main floors, with a lower level for sports and recreation. Interior alleyways and squares readily bring to mind the architecture of Arab Muslim cities, and in particular the configuration of the souks. There is a somewhat labyrinthine aspect of the interiors that confirms the relation of the design to souk layouts. A sense of awe that characterizes the entrance space gives way to a more familiar and intimate sequence in the areas near the central patio or the food court. There is a certain warmth due to the use of materials like wood, and the lighting and choice of colors make the interiors convivial and conducive to friendly meetings. The plans of the building, and in particular the roof plan, reveal the careful assemblage of square and rectangular elements in a pattern that itself seems inspired by the decorative arts of Islam.

Completed in August 2010, the student center is most readily characterized by its 10-meter- (33-foot-) tall treelike columns. These are visible both inside and outside the building near its main entrance, leading visitors into a high main transverse lobby. The building also includes a multipurpose hall that can accommodate 500, an entertainment area with a movie theater, a black box theater, and basketball, tennis, and bowling facilities. The cafeteria can seat up to 500 students and has small shops for pizza or regional cuisine.

The central patio of the building has a design that was proposed by the artist Jan Hendrix. Though born in the Netherlands, Hendrix has lived and worked in Mexico since 1978. The irregular white lines of the work, called *Helix*, are based on digitally transposed drawings by the artist and are formed with water-jet cut, painted 6-by-2.5-meter (19.6-by-8.2-foot) aluminum panels. These panels cover the four walls of the courtyard and include a 12-meter- (39.3-foot-) square column in the center of a water feature that continues the same motif. The work can be viewed from the interior hallways but also outside in the courtyard. This design does not make use of the strictly geometric patterns found in the traditional *mashrabiya*, but this source of inspiration was clearly in the mind of the artist. Though the architects have integrated a work by an artist who, like them, lives in Mexico, the affinities of their work and that of Hendrix to the aesthetics of the Middle East are apparent here. As in the case of their other buildings in Doha, Legorreta+Legorreta use heavy stone façades with limited openings on the surfaces exposed to the sun. Interior spaces are usually spacious and high, with a shaded atmosphere that offers welcome relief from the hot, bright sun.

Opposite: A generous hallway connecting to the courtyard (seen on the previous spread, visible on the left).

Preceding spread: An internal courtyard is surrounded by an irregular metallic web.

Above: buildings by Legoretta+Legoretta at Education City all have carefully planned garden and courtyard spaces.

The New Architecture of Qatar 201

Above, left: Sculptural, treelike Corten steel canopies mark both the exterior and interior.

Top: A detail of one of the façades of the Student Center.

Above, right: A detail of the steel canopies.

An interior geometric wall design
conceived by the architects.

Carnegie Mellon University in Qatar

Legorreta+Legorreta, 2008

The Carnegie Mellon building is the second facility designed on the Education City campus by the Mexico City architects Legorreta+Legorreta. It is located between Weill Cornell Medical College in Qatar and Texas A&M University at Qatar. Carnegie Mellon accepted an invitation to join Education City extended by the Qatar Foundation in 2004. There are currently 400 students from 39 countries enrolled in programs in biological sciences, business administration, computer science, computational biology, and information systems.[77] As was the case for the Texas A&M building, the executive architect for this project was Halcrow, and the same team as for the earlier building handled project management. The contractor was CCIC Tyseer Contracting JV. The design-to-delivery period for this 42,500-square-meter (457,466-square-foot) building from the groundbreaking ceremony on May 17, 2006, to completion on August 1, 2008, was just over two years, with as many as 2,300 workers present on the site 24 hours a day.

According to the architect Ricardo Legorreta, "The philosophy of the Carnegie Mellon building is connected to the social experience of the university. Carnegie Mellon wanted to be the heart of Education City. Having two sides of the building with the Green Spine in the middle was the basis of the design. Similar to buildings in other cultures, this design creates space for people to pass through and circulate."[78] With its own walkway running perpendicular to Isozaki's Ceremonial Green Spine, the structure is made (in plan) of a half circle on one side and a rectangle on the other. The rectangular and circular volumes house the classrooms, laboratories, and lecture halls and are separated from one another by outdoor courtyards. This succession of indoor and outdoor spaces creates an environment where teachers and students can interact. The palm trees and water features seen outside the building continue inside a three-story glass-ceilinged walkway. The university states that this space is "alive with greenery and flooded with natural light. Walls are made of geometric mosaics of wood and stained glass, while bridges across the walkway join the two sides of the building. The walkway opens up on the south side into the food court."[79] Beyond the food court, an assembly area can accommodate up to 400 persons with *majilis*-style seating. Both the seating arrangement and the nature of this space bring to mind local precedents. A large fountain marks the north-side VIP courtyard that is surrounded by two stories of classrooms and offices. Altogether, the facility includes 11 classrooms, 5 computer classrooms, 5 labs, 5 lecture halls, a library, 12 meeting rooms, 4 study rooms, 2 prayer rooms, 149 offices/workstations, and 2 lounges. The building also has a bookstore and a fitness area, as well as areas intended for future expansion. As is the case in other campus buildings, works of art such as a mural depicting the history of Qatar and the evolution of Doha by Doug Cooper, a professor in the university's School of Architecture, have a place of honor in the Carnegie Mellon building.

With this project, the architects succeeded in developing an unmistakable identity for the Carnegie Mellon building while still employing the careful mixture of their own cultural references with responses to local conditions and traditions already seen in the Texas A&M structure. Soaring spaces, generous shade, and warm colors are present here just as they are in the other Legorreta buildings on the campus, but even more significantly, they have taken this place and site into account. Windows on the north side or facing inner courtyards are placed to reduce solar gain, while the building's stone elements increase its thermal mass.

Opposite: Windows designed to allow light through the powerful stone façade without undue heat gain.

Preceding spread: The high, partially covered area near the entrance.

208 The New Architecture of Qatar

Above: unusual window openings, large sculptural objects and generous gardens are part of the design.

Top: The structure is made (in plan) of a half circle on one side and a rectangle on the other.

The New Architecture of Qatar **209**

Above: A rounded arch form emphasizes the semicircular plan of part of the complex.

Top: Unexpected openings mark the otherwise solid stone façades.

إن المطار ليس مجرد
مبنى ذخم أو جدران إلى
الأمام وإنما هو حوض عملية
شاملة تحتضن الحداثة
بلا تهيب وتثر من كل
جديد بدون رهبة
حمد بن خليفة آل ثاني

Shades of beige and rose mark the
stone façades of the building.

Texas A&M University

Legorreta+Legorreta, 2008

An entirely mineral courtyard with pyramidal extrusions, and the sharply cut-out façades to the rear.

The Mexican father-and-son team Legorreta+Legorreta designed the Texas A&M Engineering Building. It was the first of their four buildings on the Education City campus to be completed. Ricardo Legorreta was the first Latin American architect to win the AIA Gold Medal (2000), and he was winner of the 2011 Praemium Imperiale in Japan. He died in late 2011. Design work on the project commenced in January 2004, and the actual construction took one year and ten months, reaching completion in September 2007. The executive architect for the project was Halcrow, who was also involved with the Museum of Islamic Art in Doha and the Hamad International Airport.

The total floor area of the building is 61,300 square meters (659,828 square feet), made up of two main areas—research and academic wings linked by an atrium with a pool in the form of a star that can be emptied and used as an event space. The star pattern is found throughout the building. Indeed, the decorative elements of the project are present to the extent of becoming an integral part of the design, and are indicative of Legorreta's concept of architecture. In 2007, the architects stated, "Islamic architecture has always been an important influence in our work. The use of walls, textures, light, shadow and water allows creation of spaces that offer peace, encourage meditation, study, and conversation. With a contemporary interpretation of Islamic courtyards, textures, grills, floors and ceilings, we designed a building that represents the modern Qatar and hopefully contributes to educate the new generations that such a wonderful culture deserves."[80] The colors and materials employed by Legorreta+Legorreta in the Texas A&M building range from a rich reddish stone finish for the main entrance to yellow facades or blue interiors, such as that of the rotunda area. It cannot be said that these color schemes have any direct bearing on Qatar and its architecture, but they are clearly at home in the desert environment that they occupy. Stone surfaces were chosen to reduce heat gain, a factor more significant here than in Mexico.

The main entrance to the Texas A&M Engineering Building features a 2.5-ton solid bronze door manufactured in Saudi Arabia that opens into a three-story lobby area. The building contains four outdoor courtyards with fountains. The research rotunda has an X-shaped design with triangular skylights. The rotunda's blue color is intended to "decrease the interaction between the inside and outside world so researchers can conduct their studies in a peaceful and quiet atmosphere." A two-story library is also part of the facility. Ricardo Legorreta stated, "Very commonly, we architects design for the elevation. I design from the inside, and then I fix the elevation. I design the interior of the spaces. Interiors are architecture, it is where you live."[81]

The school offers programs in chemical engineering, electrical and computer engineering, liberal arts, mechanical engineering, and petroleum engineering as well as a science program. The inaugural class of Texas A&M at Qatar began on September 7, 2003, with 29 students; 24 were Qatari, and of these 15 were female. The student body currently comprises about 400 persons from more than 20 countries.[82] The facility was inaugurated on March 19, 2007.

Opposite: Strict window grids contrast with fountains whose design is derived from Muslim tradition.

218 The New Architecture of Qatar

Above: Stone-clad fins shelter windows to avoid excessive heat gain.

Top: There are four outdoor courtyards located within the building.

The New Architecture of Qatar 219

Above, left: Stone walls are used to shield the building from the hot sun of Doha.

Top: The research rotunda is X-shaped and features triangular skylights.

Above, right: the architects use sharply delineated cutouts in the stone façades to create a variety of patterns of sun and shade.

Glass ceiling in
the atrium.

Ministry of Finance

Kenzo Tange, 1984

The client for this project, originally called the Ministry of Finance and Petroleum Affairs, was the Emiri Diwan, and the main contractor was Midmac.[83] The six-story extension, designed by Kenzo Tange & Urtec, has a structural frame in reinforced concrete with external and internal granite cladding. Internal finishings include marble paving and cladding in the public areas and atrium. Design work on the 4,600-square-meter (49,500-square-foot) building began in 1979. Construction began in 1982; the project was completed in 1984.[84]

The building is located on the Corniche, just opposite the Museum of Islamic Art roundabout. The design stands out because the upper level of the structure, containing ministerial offices, partially overhangs another concrete structure, originally called Government House. Completed in 1969, Government House was built on landfill that extended the Corniche approximately one city block. The architect of the original building is apparently unknown. The offices of Sheikh Khalifa bin Hamad Al Thani were located in Government House until he moved to the Emiri Diwan in 1972, leading some to say that Government House was once the office of the Emir. The connection between the two buildings, now housing only the Ministry of Finance, is on the eastern side of the former Government House structure. One of Tange's gestures was to reorient the complex so that its main (VIP) entrance is on the Corniche side rather than at the rear.[85] In practice, only the minister and his guests used the ramp that leads cars up to the first-level official entrance.

Kenzo Tange (1913–2005) is one of the most important postwar Japanese architects. He was the winner of the 1987 Pritzker Prize and completed such significant works as the Hiroshima Peace Memorial Museum (Hiroshima, Japan, 1955), the Yoyogi National Gymnasium for the 1964 Summer Olympics (Tokyo, Japan, 1964), and Tokyo City Hall Complex (Tokyo, Japan, 1991). Arata Isozaki worked in the office of Kenzo Tange from 1954 to 1963, a fact that highlights the continuity of the presence of both men in the development of the architecture of Doha. Isozaki's own plan for the Corniche, involving the Qatar National Library (2000–2002), and the Qatar National Bank (2003–4) as well as other structures was not executed, but he was then made responsible for the early master plans of Education City (2002–4).

Tange was the winner of a 1976 competition for the Qatar Government Center, which was to have been located on the Corniche and to have included a palace, courthouse, and National Assembly building, as well as associated structures. The Architects Collaborative, Gunther Behnisch, and James Stirling also participated in this competition, an indication of the very high international level sought from the first where the development of Doha was concerned. Fifteen government ministries were also to have been involved in the master plan, possibly with designs by other architects following a master plan imagined by Tange, making this project in some respects similar in scale to that of Brasilia (Oscar Niemeyer, 1958).[86]

Opposite: View from the interior of the main entrance area.

Stalls in Souk Waqif, with a large pedestrian passage to the left.

Souk Waqif

Private Engineering Office, 2008

Set not far from the Museum of Islamic Art, near the middle of the Corniche in Doha, the Souq Waqif is considered an important heritage site in Qatar. When Doha was a small town, a creek ran through this site, and inhabitants gathered on the banks of the *wadi* to buy and sell goods. The renovation of the old Souq Waqif was undertaken by the Private Engineering Office (PEO) acting on behalf of the Emiri Diwan. Aside from the market, there are a number of restaurants and other amenities in the district, including new boutique hotels in a traditional architectural and decorative style, which also involve the ongoing architectural intervention of the PEO. The designer of the project, the artist Mohamed Ali Abdulla, undertook "a thorough study of the history of the market and its buildings, and aimed to reverse the dilapidation of the historic structures and remove inappropriate alterations and additions. The architect attempted to rejuvenate the memory of the place: modern buildings were demolished; metal sheeting on roofs was replaced with traditionally built roofs of dangeal wood and bamboo with a binding layer of clay and straw, and traditional strategies to insulate the buildings against extreme heat were re-introduced."[87] The area of the Souq Waqif is 164,000 square meters (1,765,300 square feet); design and construction occurred between 2004 and 2007. The completed project was shortlisted for the 2010 Aga Khan Award for Architecture.

In discussion with another important figure of local architecture, Ibrahim Al Jaidah, Mohamed Ali Abdulla explains, "I am an intruder into the art of architecture. I am a painter. . . . I was asked to put together a concept to restore Souq Waqif. I did three or four acrylic paintings. It was just my imagination working—how would I like to see this place? My father's shop was there when I was a child. I played on the roof of the souq. I knew how the Souq Waqif looked before the 1970s changed everything. His Highness liked the concept. His Highness the Father Emir was anxious for us to use traditional materials and techniques. The Souq Waqif was the chance for me to put theories into practice. The memories of people about that place are so important—they should not feel that it is not real or true. I went to the old people who had shops there and asked them what they thought."[88]

This project is of interest because of its history, the parti which consisted in studying and preserving local heritage, and the Qatari origin of the principal architect. After receiving a degree from the University of Toledo (Ohio), Mohammed Ali Abdulla became the head of the Crafts section in the Gulf States Folklore Center. He was the head of the Graphic Design section at Qatar Television for nine years before becoming the senior designer and project manager of the Souq Wakif rebuilding and restoration project. Mohammed Ali Abdulla has also worked on the restoration and reconstruction of Wakrah and the village of Al Wosail. A historian and artist, he has studied links between Kuwait, Bahrain, Saudi Arabia, and Qatar in terms of architectural ornamentation and has sought to reveal the role played by art in the construction of buildings in the region.[89]

Opposite: Though most passages or streets in the Souk are open, some, such as the one seen here, are enclosed.

About 75 percent of the structures in the Souq Waqif were restored to their original form. No cement or steel was used in the renovation work. The designer studied photographs and interviewed older residents of Doha about the site while also traveling to other countries in the region to compare the architectural language of the local markets. "The sea unified people in the region," he states. "Environmental and political factors forced people to move from one coast to another, leading to the emergence of a common culture and traditions. Their architectural style also reflects this similarity." Stone walls with clay mortar are typical of the original construction, with wooden lintels *(rukniyat)* used to support the walls. "There is nothing hidden in these buildings and the structure is quite visible. People also didn't use colors to decorate the buildings. They retain the natural color of the stones and the material used for plastering," said the architect.[90] In the place of a beach rock called *faroosh*, used in the past, a "very similar" alternative material was employed in the restoration work in order to avoid environmental damage.

The completed market recalls the history of the souq at the same time as it offers modern conveniences such as electricity, plumbing, and air conditioning, Areas devoted to spices, pets, or falcons are very much in keeping with the continuity of traditions embodied in the buildings themselves. The activity of the souk and the number of visitors, particularly at the end of the day as temperatures fall, highlight the real success of the architectural project.

The 2010 report on the Souq Waqif by the Aga Khan Architecture Award concludes, "In complete contrast to the heritage theme parks that are becoming common in the region, Souk Waqif is both a traditional open-air public space that is used by shoppers, tourists, merchants and residents alike, *and* a working market." Souq Waqif is located next to the 35-hectare site of the mixed-use Msheireb project now under construction, which has also benefited from careful study of local and regional architectural heritage, at the instigation of Her Highness Sheikha Moza bint Nasser. As the nomination for the Aga Khan Award and, indeed, the public success of the Souq Waqif demonstrate, this is a project that sets a standard for future development that respects local traditions while embracing modernity.

Preceding pages: Although completed in 2008, Souq Waqif has a very traditional appearance.

Opposite: Narrow streets are typical of traditional regional markets. The architecture echoes time-honored forms.

Covered outdoor spaces retain the
architectural rhythm of the complex.

Qatar University

Kamel El-Kafrawi, 1985

Qatar University is located to the north of Doha, 16 kilometers (10 miles) from the city center and not far from West Bay Lagoon.[91] The main campus has an area of 8 square kilometers (3 square miles). The original campus of the university, part of the New District of Doha (NDOD) conceived in the 1970s, was designed by the Iraqi-born Egyptian architect Kamal El-Kafrawi (1931–1993).

In January 1973 the architect, who lived at that time in Paris, was commissioned by UNESCO to prepare preliminary studies for a College of Education intended for teacher training. The architect moved to Doha in 1974, but a subsequent report suggested that Qatar should have a larger facility accommodating more than 4,500 students. The Emir accepted a master plan for the institution in August 1975, with detailed plans prepared by early 1976. Colleges of science and civil aviation had been added to the original scheme, as had libraries and office buildings. In respect of local traditions, separate areas for male and female students were part of the plan.

The design employs a modular grid-based low-rise scheme with precast unplastered white concrete employed for both cladding and structural walls. A factory to produce the concrete elements was established nearby under the supervision of Interbeton Ltd. (Netherlands), which allowed the project to attain high standards of quality. The octagonal basis for the plans allows classrooms to connect with lobbies that admit natural light and encourage the congregation of students. Although some freestanding buildings were part of Phase 1B of the project, no fewer than 600 octagons are linked together to form the faculty buildings and library—a point that has frequently been made with aerial photos of the complex. Wind towers are used in a repetitive pattern on each of the octagonal units that make up the main buildings. Calling on local building tradition, these towers are intended to bring cool air in and to reduce ambient humidity. Pedestrian routes within the campus were aligned with prevailing winds to provide some relief from summer heat.[92] The main campus buildings were located within a ring road with other facilities, for example those devoted to sports on the exterior of the ring. A report prepared by the Aga Khan Trust for Culture states, "Towers of light are also introduced to control the harsh sunlight, and abundant use of *mashrabiyas* and some stained glass also serve to temper the environment. Open and partially covered courtyards, planted and often with fountains, are plentiful throughout the site."[93] It may be noted that although nominated, Qatar University was not a recipient of the Aga Khan Award for Architecture, contrary to what some sources indicate. The university was inaugurated in February 1985, and the total built-up area in 1992 exceeded 100,000 square meters (1,076,391 square feet). In fact, the complex was originally designed to the German standard of 24 square meters (258.3 square feet) per student in the teaching areas, and no less than 45 percent of the built area was used for circulation.[94]

Opposite: Wooden screens and internal gardens dot the otherwise modern buildings

242 The New Architecture of Qatar

Above, left: The architecture is a subtle mixture of modern and traditional Muslim ideas.

Top: Qatar University with the towers of West Bay in the background.

Above, right: A screen echoes a *mashrabiya*, whose concept dates back as far as the twelfth century.

The New Architecture of Qatar **243**

Above, left: The main entrance lobby.

Top: Natural light is admitted in an oblique fashion to protect against heat gain.

Above, right: A square opening leads to one of the exterior garden areas.

لطفاً
ممنوع التدخين
NO SMOKIN

Qatar University (QU) is the only government university in Qatar, though the rise of Education City has diversified the programs offered to potential students. The areas of concentration at QU have been arts and sciences, business and economics, education, engineering, law, sharia and Islamic studies, and a College of Pharmacy created in 2006. A reform of the institution focusing on "autonomy, decentralization and accountability" was launched in 2003. One goal of the changes introduced at that time was the support of "Qatarization," or encouragement to local citizens to take an increasingly active part in the destiny of their country and to maintain cultural and national identity. Another, separate institution, the College of the North Atlantic, was created nearby in 2002, to the south of QU.

A number of new buildings have recently been added to the campus, starting with one for classrooms and another that is a food court, totaling 20,910 square meters (225,073 square feet), both located in the female section of the campus. Shannon Trading & Contracting, which has been present in Qatar for over thirty years, was responsible for the construction of these buildings. The classroom building has 42 classrooms and a capacity of 1,200 female students. The food court has 10 restaurants with a capacity of 800 persons. The new master plan that was approved by the Qatar University Board of Trustees in July 2006 included the construction of five new buildings. Amongst these, the research center complex (18,000 square meters; 193,750 square feet) contains a main administrative block, 6 research blocks with offices and laboratories, and an animal house. A new library (37,000 square meters; 398,265 square feet), and the School of Business building (25,960 square meters; 279,431 square feet) are also part of the current scheme. Arab Group Architects designed the master plan and new buildings.[32] The new buildings, set in generously spaced sites on the northern side of the campus, are in an efficient and solid style that certainly compensates for the rather complex circulation within the original buildings of the university. Yet, unlike the campus inaugurated in 1985, here users who arrive on foot are immediately exposed to the hot sun. References to Islamic architecture are also less evident in the new buildings than they were in the El-Kafrawi designs. "I do not claim to have produced the perfect design for the University," wrote Kamal El-Kafrawi in 1983, "but would rather suggest that this work be seen as the first stage of a continuing architectural study, directed towards a modern expression of Islamic architecture."[95] The original Qatar University campus did in any case represent a significant contribution to the search for a modern expression of Islamic architecture, and a clear, early confirmation of the interest of the State of Qatar in the best of modern design.

Opposite: Wind towers are used in a repetitive pattern on each of the octagonal units that make up the main buildings.

Near the main entrance to Mathaf:
Arab Museum of Modern Art.

Mathaf: Arab Museum of Modern Art

Jean-François Bodin, 2010

Designed mainly to house exhibitions involving works drawn from a groundbreaking collection of six thousand pieces of modern Arab art dating from the 1840s to the present, Mathaf, which means "museum" in Arabic, is located in a converted school building at the western edge of Education City.[96] HE Sheikh Hassan bin Mohamed bin Ali Al-Thani, vice chairperson of the Qatar Museums Authority (QMA), formed this outstanding and unusual collection.

The noted French museum and exhibition architect Jean-François Bodin redesigned the Mathaf building in a brief period of time. Design began in August 2009, and the building was inaugurated on December 30, 2010. Bodin, born in 1946 in Paris, was a cofounder, with Andrée Putman, of the noted interior design firm Ecart International (1979), where he remained until 1988. He has worked on the renovation of numerous museums including the Musée Matisse (Nice), the Musée d'Art Moderne de la Ville de Paris, Cité de l'Architecture in Paris (2003–7), and the Musée Picasso, as well as a large number of temporary exhibition designs.

Although a new building had been envisioned for Mathaf, it will operate for the foreseeable future from this 5,500-square-meter- (59,200-square-foot-) facility, which includes twelve galleries on two levels, a café, museum shop, research library, an education wing, and offices. The executive architect for Mathaf was Burns & McDonnell, and the contractor was Confidence Engineering and Development. Project management was in the hands of the Qatar Foundation Capital Projects Directorate, Qatar Petroleum Onshore Engineering Department, and KEO International.

The outdoor terrace in front of the museum, whose façade is fashioned with scaffolding, is used to exhibit sculptures. Like the scaffolding seen outside, the interior of Mathaf has a voluntarily "industrial" or perhaps temporary appearance, which is particularly well suited to the modern art it displays. In fact, the ambiance within Mathaf varies considerably, with the temporary aspect being much less evident in most of the galleries. The architectural approach has consisted in leaving most of the shell of the building intact while substantially modifying interiors for their new function. The original central playground and two lateral courtyards were converted by Bodin into the lobby of the new structure as well as double-height galleries. With the building's somewhat labyrinthine design, the galleries are often presented as a stark contrast between well-lit works and dark walls. Mathaf offers many surprises, not the least of which is the idea of a narrative, introduced by Bodin in the gallery sequence itself. Where some might expect a carefully contrived "white cube" atmosphere in such a new facility, Bodin has used his extensive Parisian exhibition-design experience, combined with an appreciation of the program and ambitions of Mathaf, to give the space a new, rather complex feeling and appearance. The strong impression of discovery elicited by modern Arab art for most visitors is thus complemented and, indeed, augmented by an appropriate, contemporary interior design.

Opposite: Interior gallery spaces are relatively intimate and have little natural light.

tea with nefertiti

نفرتيتي إن حكت

Landscaped courtyards and atria
interspersed throughout the building.

Georgetown University School of Foreign Service in Qatar

Legorreta+Legorreta, 2010

Beginning in 2006, Legorreta+Legorreta designed the building for the leading school of international studies, with a floor area of nearly 40,000 square meters (430,556 square feet).[97] The school provides studies concentrating on international politics, culture and politics, and international economics. The building also houses the Center for International and Regional Studies (CIRS), which is located in the central courtyard of the academic area. As the university describes the facility, "Ample outdoor space and courtyards allow natural light to penetrate into the building's interior. Columns along the building's entrance are being inscribed with poetry that reflects Georgetown's commitment to knowledge, inquiry, diversity and dialogue."[98]

Here, as in its other Education City projects, Legorreta+Legorreta has sought to achieve a synthesis between its own philosophical base in Mexican society with the cultural and environmental realities of Qatar. In this instance, the architects also undertook a study of the teaching methods and atmosphere of Georgetown University in Washington, D.C., so that the new facility would have some relationship to the parent institution. Explaining their *parti* with relation to the desert site and the specific functions of the building, the architects explain, "Landscaped courtyards and atria interspersed throughout the complex of the building are intended to bring a tranquil feeling to the day-to-day activities and promote a sense of intimacy within the spaces that are orientated to look onto these richly landscaped oases. Special attention is given to the outdoor environment. Water features refresh and ventilate the spaces around them. A cactus garden is located along the north façade and marks the transition between the desert and formally designed areas."[99]

The executive architect for this project was Langdon Wilson International, and the general contractor was Midmac. The Qatar Foundation Capital Projects Directorate, the Qatar Petroleum Onshore Engineering Department, and KEO International handled project management.

The building is conceived as the accumulation or intersection of five volumes, respectively housing the common space that is at the core of the design, an auditorium seating 350 persons, another area for the CIRS, an office block, and the library. An alternation of shaded interior spaces with bright, open exterior courtyards maintains a contact between the facility and its environment. This composition is intended in the final analysis to give a "village-like character" to the whole facility. One of the main access points leads directly to the common space that in turn offers access to the rest of the building. Georgetown Qatar's library houses one of the country's most extensive collections of books and other materials, with over 125,000 volumes, nearly 5,000 DVDs, and more than 500,000 e-books available for use by students, faculty, and staff as well as members of the local community. The London School of Economics, the first U.K. institution of higher learning installed at Education City, operated out of the upper level of the library, at least on a temporary basis. The ample students' common space has soaring ceilings that admit natural light while sustaining cool interior temperatures and the overall feeling of solidity that dominates the Legorreta+Legorreta buildings on the Education City campus. The official opening of the facility took place on January 13, 2011, in the presence of Her Highness Sheikha Moza bint Nasser, chairperson of the Qatar Foundation.

Opposite: The students' common space has soaring ceilings that admit natural light while sustaining cool temperatures.

Al Wakrah, Lusail

The minaret of the Al Wakrah Heritage Village Mosque.

Heritage Villages

Private Engineering Office, 2010

Qatar, more than many neighboring Gulf countries, has made a concerted effort to restore and rebuild many old houses or areas of historic interest. The Souq Waqif is an example of the approach that has been taken, largely under the supervision of the Private Engineering Office (PEO) that carries out projects of interest to His Highness the Emir. Two other significant projects outside of Doha have been completed by the PEO, one to the south of the city in Al Wakrah, and the other to the north in Lusail.

Between 1800 and 1860, Qatar was under the control of the Khalifa rulers of Bahrain. In 1825, one of the rulers of Bahrain, Abdullah bin Ahmad Al-Khalifa (second Hakim of Bahrain; ruled 1796–1843), started to heavily tax the villages of northern Qatar. In order to avoid taxation, members of the Bu 'Aynayn tribe moved south and established a settlement at Wakrah in 1828. Conflicts continued with the Bahrainis until they destroyed both Doha and Al Wakrah in 1867. Fearing that pirates might establish themselves in Doha or Wakrah, the British made agreements with the Al Thani and Al Khalifa families to remain in their respective territories. Both Doha and Wakrah were then rebuilt. Al Wakrah, for all intents and purposes, became the second largest city of Qatar and is listed in the *Gazetteer of the Persian Gulf, Oman and Central Arabia* (1908), compiled and written by John Gordon Lorimer (1870–1914), an official of the Indian civil service.

The political situation in Al Wakrah remained unstable despite the British intervention. Sheikh Jassim bin Mohamed Al Thani, the founder of modern Qatar, sent one of his sons, Abdulrahman (1871–1930), to be the ruler of Al Wakrah in 1906. Another son called Abdullah was sent to rule Doha. Unsurprisingly, the Bu 'Aynayn resisted his efforts to collect taxes. In 1907, the Bu 'Aynayn decided to leave Al Wakrah, and the town was almost completely deserted beginning in 1922. Local custom allows unoccupied houses to be used only with the permission of the owner. Since people coming into Al Wakrah could not find the rightful owners, they started to build around the deserted houses that had formed the core of the old city. In aerial photos taken in 1952, the oldest part of the town is deserted and almost in ruins.

In the 1980s, the municipality of Al Wakrah decided that the deserted houses were dangerous, and that they needed to clear the area. Everything was destroyed. Mohamed Ali Abdulla, who led the PEO team that carried out restoration, states, "When I started working on the town, there was a concrete municipal building that had been erected on the site, with a car park that occupied twice as much space as the structure. Fortunately, when they bulldozed the area, they did not destroy the foundations of the old buildings—they just cleared the surface. For the car park, they just added some sand and tarred over the space. When I had the asphalt removed, all of the foundations were visible. Based on these foundations and the 1952 aerial photos, we were able to rebuild the old town. The space not occupied by the municipal building and its car park had simply stayed empty, but there too, the foundations remained. When the government bulldozed the area, they paid what owners they could find and they sent a surveyor to measure the exact number of square meters of area that was involved. I was able to obtain those documents from the municipality. I could compare the aerial photos, the acquisition documents and the foundations." It was thus that approximately 300 houses and 250 shops, together with seven mosques, were rebuilt.[100]

Opposite: A typical street view of Al Wakrah Heritage Village.

Pages 266–68: A courtyard of a wealth family's house, and the entry doors of the Al Wakrah Heritage Village fish market.

270 The New Architecture of Qatar

Preceding page: Al Wakrah door (detail).

Above: A detail of a clay wall in Lusail Heritage Village.

Above, left: A typical living room in a house in Al Wakrah Heritage Village.

Top: Al Wakrah Village shops near the beachfront

Above, right: Typical door detail in Al Wakrah Village.

His Highness the Emir knew Wakrah from the period of his childhood, and in late 2006 he asked the PEO if it might be possible to reconstruct part of the old town. Mohamed Ali Abdulla and his team found that a much larger restoration of the old heart of Al Wakrah was possible. Using a combination of aerial photos, the town survey dating from the 1950s, and extensive interviews of old people from the area, the PEO worked on the project between 2007 and 2010, when it was completed.

The construction methods employed were traditional. Mohamed Ali Abdulla states, "His Highness is very attentive to how we treat the old buildings. When I was working on Souq Waqif, he told us several times, no concrete, no steel, no cinder blocks. He visited the site almost every afternoon. We are using stone and gypsum. Before, they used earth and stone, but the earth is not that good. Earth stores a good deal of humidity. If there is any under the ground, it seeps into the earth. Gypsum is stronger. They used some coral as well—but in order not to ruin the sea, we have used a material that is similar."[101]

Like the similar project in Lusail, the Wakrah Heritage Village is due to be opened to the public in the future. As Nasser Ismail Ali Amadi, who works with QMA states, "There is the QMA project, which includes the Pearl Museum, and also a creative hub and the regeneration of the village. It will be for creative people—artists, for example. There will be craftsmen—old crafts and new types of creativity."

The Lusail Heritage village, also completed in 2010, is located near the Losail International Circuit. Its area is 200 meters by 1,300 meters, or 260,000 square meters (656 feet by 4,265 feet; 2,800,000 square feet).[102] The site is divided into two areas: a northern section, which has 52 houses and 2 mosques, and the southern zone, with a further 13 houses, a mosque, and a fort that was built and occupied by Sheikh Jassim bin Mohamed Al Thani and his entourage. After the death of Sheikh Jassim in 1913, the Lusail site was abandoned. By the 1950s, when Doha began to flourish, contractors went to abandoned villages to collect any stone they could resell in the capital. The foundations, set well into the earth, were left, and once again the PEO was able to reconstitute the complex.

The Lusail reconstruction project is also awaiting use. Mohamed Ali Abdulla feels there will indeed be good use for the work of the PEO. He pleads for a new look at traditional buildings. "The people who built houses like they still did in the 1950s took almost one thousand years to get to that point. Why shouldn't we use what they knew and use our research centers, architects, and engineers to bring their knowledge into a new era? Socially, this architecture was suitable for us, spiritually and environmentally as well. Maybe people are fed up with living in towers where every movement is controlled."[103]

Following spread:
Lusail Village mosque

Opposite: Courtyard view of a typical house in Lusail Heritage Village.

Above: A courtyard entry door in Lusail Heritage Village.

The New Architecture of Qatar **277**

Above, left: The courtyard of the house of a wealthy family.

Top: A full view of the Lusail Heritage Village.

Above, right: Typical house façades in the Lusail Heritage Village.

Map of Projects in Qatar

EDUCATION CITY

- QATAR SCIENCE & TECHNOLOGY PARK
- SIDRA MEDICAL AND RESEARCH CENTER
- QATAR NATIONAL CONVENTION CENTER
- WEILL CORNELL MEDICAL COLLEGE
- CARNEGIE MELLON UNIVERSITY IN QATAR
- GEORGETOWN UNIVERSITY SCHOOL OF FOREIGN SERVICE
- LIBERAL ARTS & SCIENCE BUILDING
- TEXAS A&M UNIVERSITY AT QATAR
- STUDENT CENTER
- MATHAF: ARAB MUSEUM OF MODERN ART
- CEREMONIAL COURT

Jeryan Nejaima
College of t
Je
Hazm A
Landmark Shopping Ce
Dahl Al Hamam
Madinat Khalifa North
Al Luqta
Al Shagub
Madinat Khalifa South
MATHAF ARAB MUSEUM OF MODERN ART
AL SHAQAB
Lebbay
Fereeh Al Zaeem
Old Al Rayyan
Al Messila
Al Rayyan Park
New Al Rayyan
Muraikh
Mehairja
TORCH
Baaya
Fareej Al Soudan
Muaither
ASPIRE ZONE
Al Waab
Al Aziziya

2 km / 1 miles

D E F

MIA & PARK

- HOTEL GRAND HYATT
- KATARA CULTURAL VILLAGE
- West Bay Lagoon
- THE PEARL QATAR
- Jegtaifiya
- Doha Exbitions Center
- The Saint Regis
- Al Gassar
- Onaiza
- WEST BAY
- Al Markhiya
- Lejbailat
- Al Dafna
- IMAM ABDUL WAHHAB MOSQUE
- HILTON HOTEL
- HOTEL SHERATON
- MUSEUM OF ISLAMIC ART
- RICHARD SERRA SCULPTURE
- Al Ahli Hospital
- Sidra Medical and Research Center
- Wadi Al Sail
- CENTRAL POST OFFICE
- NATIONAL THEATRE
- Old Palm Tree Island
- ereej Bin Omran
- Rumaila
- Hamad Medical City
- New Al Hitmi
- HAMAD GENERAL HOSPITAL
- Diwan Al-Amiri
- MUSEUM OF ISLAMIC ART
- Doha Port
- Doha Harbour
- MIA PARK
- Al Bidda
- Emiri Palace
- Qatar Museum Authority
- Qatar Islamic Cultural Centre
- SOUQ WAQIF
- ORIENTALIST MUSEUM
- SHARQ VILLAGE & SPA
- Fereej Mohammed Bin Jasim
- Al Najada
- Al Hitmi
- Mushaireb
- Barahat Al Jufairi
- Al Rufaa
- Al Sadd
- Fereej Bin Mahmoud
- Fereej Al Asmakh
- Old Al Ghanim
- Fereej Abdel Aziz
- Umm Ghuwilina
- Doha Clinic Hospital
- Al Doha Al Jadeeda
- Al Mirqab Al Jadeed
- Fereej Bin Derhem
- Fereej Al Nasr
- Rawdat Al Khail
- Najma
- Al Mansoura
- HAMAD INTERNATIONAL AIRPORT
- New Slata
- Al Hilal
- Maamoura
- Atlantic
- ej Kulaib
- UNIVERSITY

Cultural Projects

Abu Al-Qabib Mosque

Mohammed Ali Abdullah, PEO, 2012

Although it appears to be a newly restored building, the Abu Al-Qabib mosque near Souq Faleh in Doha is a new structure, built using traditional techniques and materials. With its 44 small domes, the structure immediately stands out from other mosques, on which domes are rarely present in such large numbers.[104] The reasons for this unusual configuration can surely be found in the traditional architecture of the region. At the end of February 2012, Prince Badr bin Jelowi, governor of Al-Ahsa in the eastern province of Saudi Arabia, reopened the historic Al-Jabri mosque following the completion of several years of expansion and maintenance work. This mosque was built in 1479, during the period of the Jabria State. The Jabrids were a Sunni dynasty that dominated eastern Arabia in the fifteenth and sixteenth centuries. The Al-Jabri mosque originally had a large number of small domes, as early aerial photos of Hofuf attest, making it one of the earliest known examples of multidome mosque architecture in the region.[105] Similar designs have existed in Dhahran and elsewhere in the eastern Arabian Peninsula not far from Qatar.[106]

The next step in this story brings it to Doha. Originally erected in 1878 at the request of Sheikh Jassim bin Mohamed Al Thani (1825–1913), the founder of modern Qatar, Al-Qabib mosque was based on an example found in the north of Qatar, 100 kilometers (62 miles) west of Doha.[107] The artist Mohammed Ali Abdullah, designer of the Souq Waqif, worked on the most recent version of Abu Al-Qabib mosque and states, "Sheikh Jassim wanted to double the size of the mosque in Al Zubarah, which had 21 domes. The structure in Doha is thus built on a 4-by-11 grid, whereas the one in Zubarah had a 3-by-7 grid. "The original Abu Al-Qabib was demolished sometime by the mid-1960s, making way for a more modern concrete block structure."

In 1998, the mosque was again rebuilt by the building engineering department of the Ministry of Municipal Affairs and Agriculture. The client was the Ministry of Awqaf and Islamic Affairs, and the designer at that time was Mohamed N. Al-Baker. Design work started in March 1996, and construction was completed in July 1998. The fourth and most recent incarnation of Abu Al-Qabib was inaugurated by the Ministry of Awqaf and Islamic Affairs on July 20, 2012. The new structure is slightly larger than the 1998 mosque but apparently follows the 1878 design. It has also an open yard and various service facilities such as ablution places and the imam's rest house.[108] Mohammed Ali Abdullah, who works for the Emir's Private Engineering Office (PEO) explains, "In 2008, His Highness the Father Emir was not happy about the 1998 mosque. He wanted to bring back the original one. Reconstructing the original building was feasible because we have aerial photographs dating from 1947 that show the building almost from 360 degrees."[109] Using stone, gypsum, and some wood, Mohammed Ali Abdullah, working with the PEO, rebuilt the mosque entirely. "The complicated part of the design is the domes," he says. "They used to make the domes without any shuttering or formwork. An old mason described the dome-building method to me in the 1980s. I understood it on a theoretical basis but not in practical terms, so Abu Al-Qabib represented an experiment for me in the real world."

Much as the influence on the original Al-Qabib mosque in Doha came from elsewhere, so the recent reconstruction efforts have sown their own seeds. "His Highness had the idea of creating a State Mosque that would be representative of Qatar," says Mohammed Ali Abdullah. "I was asked if it was possible to use the ideas of the Abu Al-Qabib mosque on a larger scale. I did three conceptual paintings, depicting the grand mosque but with the spirit of the Abu Al-Qabib mosque. This type of mosque was actually a very old tradition in the area, and it was about to disappear, but I think that there is something of its spirit in the new Imam Muhammad Ibn Abdul Wahhab Mosque."[110]

Phase 1 of MIA Park

Pei Partnership, 2011
A 28-hectare (69-acre) park, including Richard Serra's sculpture *7*, inaugurated on December 16, 2011. *Featured on page 38.*

Katara Cultural Village

Consult Maunsell, 2010
A series of cultural spaces including an amphitheater, museums and restaurants located near West Bay. *Featured on page 180.*

Mathaf: Arab Museum of Modern Art

Jean-François Bodin, 2010
Exhibitions and a permanent collection of Arab modern art, located at Education City in a former school. *Featured on page 248.*

Omar bin Al-Khattab Mosque

Design Studio, 1984

The Omar ibn Al-Khattab mosque is located in the Madinat Khalifa South area of Doha, near Omar bin Khattab Street and the embassy of the United States.[111] It is a modern reinforced concrete structure that occupies almost its entire site of 7,608 square meters (81,900 square feet). Built in 1984, it can receive up to 4,000 worshippers simultaneously. The spacious main prayer hall has an area of 1,175 square meters (12,650 square feet), accommodating up to 1,130 worshippers. The somewhat unusual architectural design includes a hemispherical dome with a small central oculus surrounded by four half domes, which are marked by semicircular stained-glass windows representing a stylized sunburst. Supported by four large square columns, the main dome sits entirely above the ground-floor prayer area, while three of the half domes are located above the upper-floor prayer areas, and the fourth on the side of the *qibla* wall. The low central dome is hardly visible from street level, and the half domes cannot be seen from the exterior. Set to one side of the *mihrab*, the *minbar* (pulpit) is of carved wood. The *mihrab* itself is also outlined with a narrow band of stained-glass windows. Aside from the colored glass, geometrically carved woodwork, a plinth course in pink marble, and carved screens made with fiberglass, the mosque is relatively austere, both in its interior and exterior forms and finishes. Some geometric detailing distinguishes the otherwise relatively rectilinear and strict exterior of the building. Eight arched windows complement the lighting of the interiors of the prayer area. The mosque is clearly modern in form. The plans of the structure were drawn up by a Polish consultant firm called Design Studio.[112]

The 40-meter- (131-foot-) high, two-story structure is coated with a product called Mineralite, a cement-based final render coat, finished to expose durable natural aggregates, which include glass in this instance, giving the building a shiny appearance when viewed from certain angles. Mineralite is used in the most visible areas of the façade, resulting in a nearly seamless finish that underlines the strong blocks that make up the essential design. There are three library spaces in the connected services building, one located on the ground floor (28 square meters; 301 square feet) and the other two 40-square-meter (430-square-foot) areas on the first floor. A courtyard within the precinct of the mosque near the main entrance provides an open space of 380 square meters (4,090 square feet). Although somewhat worn by time, the Omar ibn Al-Khattab mosque is on the whole in good condition, both inside and out.

Omar (or Umar) bin Al-Khattab (586–644) was the second caliph of the Rashidun caliphate, which controlled the Arabian Peninsula and the present area of Qatar in the seventh century. He is known as one of the most influential Muslim rulers and was a companion of the Prophet. The significance of the Omar ibn Al-Khattab mosque within Qatar and beyond has been further underscored by regular Qatar Television broadcasts of Friday sermons given by such figures as the prominent Islamic scholar Sheikh Yousuf al-Qaradawi.

Qatar National Theatre

Ahmad Cheikha, 1982

The Qatar National Theatre was designed by a collaborative called Triad-CICO, made up of Ahmad Cheikha of CICO Consulting Engineers, founded in 1967 in Doha, and James Connell, son of Amyas Connell, the founder of the Nairobi firm Triad Architects. The London firm Theatre Projects Consultants was also involved in the design. The client was the Ministry of Municipal Affairs and Agriculture. Paired with the Ministry of Information, the theater project was part of an effort to create a new complex of government and cultural buildings along the Corniche. It was the first element in a broader master plan that at the time included shops, restaurants, galleries, and other amenities. The buildings were imagined as a link between the governmental offices on the Corniche to the east and the planned New District of Doha. Located between the Corniche and Majlis Al Taawon Street on a 37,000-square-meter (398,000-square-foot) site, the Qatar National Theatre complex, originally commissioned for design in 1972, was inaugurated in 1982 as the state's official theater, and it seats 490 spectators.

There are two reinforced concrete buildings in the complex, one for the Ministry of Information (2,490 square meters; 26,800 square feet) and the other for the Qatar National Theatre (4,350 square meters; 46,820 square feet). Plans for a future art center were also part of the scheme at the time, but they were not carried out. The buildings are connected by a large rectangular courtyard with simple or severe arches and a white plaster finish that is reminiscent of earlier local architecture.[113]

These elements were posited by the architects as linking features that might have carried over into future nearby buildings. Twice nominated for the Aga Khan Award for Architecture, the structure is notable for its references to tradition and its very human scale. Indeed, given the participation of the local firm CICO, the Qatar National Theatre, whose program development started in 1972, might be considered one of the very early efforts to create a substantive connection between the development of the modern city and a feeling of "rootedness" in local tradition.

The Museum of Islamic Art

I. M. Pei, 2008

The top regional museum of Islamic Art located on the Corniche, with interiors by Jean-Michel Wilmotte. *Featured on page 22.*

Our Lady of the Rosary Catholic Church

Lorenzo Carmellini, 2009

The 2,700-seat Catholic church[114] was consecrated and dedicated on March 14, 2009, in an occasion that Vatican Radio called "an event of historical importance after fourteen centuries."[115] Under the control of the Apostolic Vicariate of Northern Arabia, the church is intended for approximately 100,000 Christians who live in Qatar, mainly transient expatriates of Philippine origin, although a total of 60 nationalities is represented in the congregation. The church is located in the southern outskirts of the city in Mesaymir on land donated by the His Highness the Emir and leased for a nominal fee.[116]

This is the first Christian church built in Qatar, although Fr. Adriano Benini has been present in Qatar since December 1970.[117] Qatar's constitution guarantees the freedom to practice religion, in line with early Islamic practice.[118]

The architects and designers of the church are the firm Spatium from Milan. Lorenzo Carmellini is an interior designer. Carmellini has worked with the architect Rocco Magnoli since the 1970s. They formed the office Laboratorio Associati in 1978 and, in 2001, Spatium in Milan. In 1979, Gianni Versace invited the team to design his boutiques. They have also designed a large number of hotels in London, Venice, Corrina d'Ampezzo, and Prague. Renato and Loredana Casiraghi, who have been present in Qatar since 1975, also played a significant role in the process. Renato Casiraghi is the managing director of the locally based construction company Prisma International, which built the church. The firm was mandated in 1994 by the apostolic vicar of Arabia, Bishop John Gremoli, to realize his "dream," which was to build precisely such a church. In 1996, Casiraghi contacted the architects and the artist Valentino Vago for the project.[119] The State of Qatar and the Vatican established diplomatic relations in 2003, and authorization to build the church was given in 2006. The complex also includes a 300-seat chapel, a building for priests and staff offices, 40 classrooms, and 10 community rooms, all designed by Rocco Magnoli and Lorenzo Carmellini, together with Renato Casiraghi, in "a style that is as close as possible to that of Arab tradition in terms of the materials and even colors."[120] The exterior of the church has no cross, bell, steeple, nor any signs. The interiors and finishes were the work of Loredana Casiraghi.

The church interior is marked by no less than 12,000 square meters (129,000 square feet) of fresco paintings in a gamut of colors ranging from blues to pinks executed by the artist Valentino Vago. The stained-glass windows of the church, which are the work of the French artist Emile Hirsch (1832–1904), were bought, restored, and transported to Doha by the Apostolic Vicariate of Northern Arabia.

288　The New Architecture of Qatar

Heritage Villages, Al Wakrah, Lusail

Private Engineering Office, 2010
Two traditional Qatari villages outside of Doha completely rebuilt according to their original appearance. *Featured on page 262.*

Souk Waqif

Private Engineering Office, 2008
Market place near the center of the Corniche in Doha, rebuilt with traditional methods and according to regional prototypes. *Featured on page 228.*

Imam Muhammad Ibn Abdul Wahhab Mosque

Private Engineering Office, 2011
The largest mosque in Qatar, built within the site of West Bay in the Al-Khuwair area of Doha. *Featured on page 68.*

Government Buildings & Health Facilities

Anti-Doping Lab Qatar

Albert de Pineda, 2012

The Anti-Doping Lab Qatar (ADLQ) announced its initiative to establish an anti-doping testing and research facility in Doha's Aspire Zone on March 16, 2010. It is the region's first specialized anti-doping laboratory. It operates independently of Qatar's existing sports organizations and has its own governing structure, accredited by the World Anti-Doping Agency (WADA). As there are only thirty-five WADA-accredited labs in the world, the importance of this initiative is evident. Research into prohibited substances and their effects on health is also part of the mission of the ADLQ.[121] Dr. Mohammed Al Maadheed, the director general of ADLQ, states, "We are very excited about this project and its implications for Qatar and the region. Athletes in Qatar will benefit from the laboratory's activities, which will ensure fair and honest competition and protect their health. Furthermore, the testing provided at our facility, accompanied by our ongoing research program, will significantly advance the wider struggle to eliminate drug use in sports and promote healthy and drug-free athletics."[122]

The architect of the 12,000-square-meter (129,166-square-foot) building is Albert de Pineda Álvarez. In 1991 he created his own office, PINEARQ, specializing in hospitals and nursing care. Located in the Aspire Zone, the ADLQ is across the road from the ASPETAR Qatar Orthopedic and Sports Medicine Hospital. Khalifa Stadium and the Aspire Tower are also close by. The building is characterized by a high, essentially flat roof and light, elegant supporting columns. Structures inspired by the wind towers present in regional architecture emerge from the roof plate, showing the subtle way that the architect has engaged himself with designs from the Middle East. Albert de Pineda likens the roof to a "fifth façade." Unlike many other health facilities, the ADLQ building was designed with a high level of security in mind, in keeping with the confidentiality of test results and their potential importance for sporting careers. The traceability of each sample must be fully ensured to uphold the credibility of the testing process, and the careful checking and storing implicated by this process have influenced the architecture of the building.[123]

According to the architect, "The idea of the project is to create a free space which is supported by a forest of columns and the presence of a wind tower, which is an urban symbol and a cultural reference element." He explains that the building has a U shape that generates an inner patio with a pond, which encourages air currents that ventilate the building. As the architect describes the interiors, here too he has taken into consideration regional architecture in the spirit of his project. "The interior design," he says, "recalls oriental palaces and mosques because of the use of columns, the connection with the outside, creating shady and cool areas, because of the use of ground water."[124] Qatar Design Consortium was responsible for the work on the structure and installations of the building, with site management handled by Projacs International / Aspire Zone.

Sidra Medical & Research Center

Pelli Clarke Pelli and Ellerbe Becket, 2012

Born in 1926 in Tucuman, Argentina, Cesar Pelli immigrated to the United States in 1952 and attended the University of Illinois, where he received his master of architecture degree (1954). He worked in the office of Eero Saarinen from 1954 to 1964 and then joined DMJM, Los Angeles, first as director (1964–66) and then as vice president of design (1966–68). In 1977, he became dean of the Yale University School of Architecture and also founded Cesar Pelli & Associates. In 2005, his firm was renamed Pelli Clarke Pelli Architects. In 1995, the American Institute of Architects awarded him its Gold Medal. He also received an Aga Khan Award for Architecture for the design of the Petronas Towers (Kuala Lumpur, Malaysia).

Located on the northern side of the main roundabout near the Education City campus, the Sidra Center is a world-class healthcare facility that is linked to the Weill Cornell Medical College.[125] Its large, arcing volumes in steel, glass, and ceramic tiles are visible from a certain distance and, in a way, form a symbolic gateway to Education City when approached from the east, which is to say the direction of Doha. According to the architects, "The 380-bed hospital is divided into three 'hospitals within a hospital' that focus on children's health, women's health, and adult acute care. The identity of each hospital is articulated by a sweeping atrium form with dedicated drop-off and entrance zones from both street level and underground parking level."[126] Green spaces within the atriums, visible from the hospital rooms, are imagined as "healing gardens" for the patients. An emphasis has been placed on the use of natural materials such as wood, granite, and marble, employed in public spaces. The executive architect for this project was Ellerbe Becket, and the contractor was an international consortium including OHL and Contrack. It includes a 273,000-square-meter (2,938,547-square-foot) hospital building and out-patient clinic and a central service building. Design started in December 2005, and the building was completed in late 2012.

Hamad Medical City

FEDCON/NBBJ, 2003–ongoing

Hamad Medical Corporation (HMC) is the largest nonprofit healthcare provider in Qatar, providing 90 percent of all secondary and tertiary healthcare services in the country. It was established by Emiri decree in 1979 and reports to the Supreme Council of Health. HMC manages eight hospitals: Hamad General Hospital, Women's Hospital, Rumaillah Hospital, Al-Amal Oncology Hospital, the Heart Hospital, Al Wakra Hospital (South Area Hospital), the Cuban Hospital at Dukhan, and Al-Khor Hospital (North Area Hospital). In 2004, the educational activities of HMC were extended to include medical students of Weill Cornell Medical Collage in Qatar,[127] confirming that the organization focuses on providing healthcare but also on teaching future doctors. The operational base of HMC is Hamad bin Khalifa Medical City, the first complex of its kind in the region, located on Al Rayyan Road near the Sports Roundabout in Doha. Currently, a major expansion of facilities is under way in Hamad bin Khalifa Medical City, including new hospitals for women, day surgery, and rehabilitation as well as the Translational Research Institute for medical sciences. The ongoing projects are part of an overall upgrading of the facilities. John Lambert-Smith, executive director of

Al Wakrah Hospital

health facilities planning and design at Hamad Medical Corporation, explains, "All of the older hospitals are being upgraded internally to create a five-star environment for the patient. We are presently lobbying to upgrade the exteriors as well. We aim to finish the interiors of the older hospitals at the same time as the three new hospitals—the Women's Hospital, the new Day Surgery, and Rehabilitation Hospitals—open. There will be a consistency to the aesthetic approach of the patient care environment."[128]

Dr. Hanan Al Kuwari was appointed managing director of HMC in July 2007. Dr. Al Kuwari and the Minister have strongly underscored the relationship between the quality of the healthcare environment, in terms of equipment and space, but also of design, with the desired excellence of patient care in Qatar. The new main buildings at Hamad Medical City were completed (shell and core) in 2006, under the authority of ASHGHAL, with FEDCON/NBBJ acting as architectural consultants, Hill International as project managers, and J&P as the contractor. Granary Associates, an architecture, interior design, and project management firm, was named the healthcare planner and architect for Hamad Medical City.

GHD Doha, 2011

Al Wakrah, with a population of about 30,000 persons, is located south of Doha and north of Mesaieed. As part of an ambitious effort to make the healthcare system of Qatar one of the most modern in the world, it was decided to build a state-of-the-art hospital in Al Wakrah. Construction began in 2007, and the facility received its first patients in April 2011. The principal consultant for the design and post-contract supervision of this 306-bed facility is GHD. The firm explains, "The design is based on concentric circles, evocative of a stone thrown in a pond, to symbolize the outward growth of the hospital as it expands into the future. The circular design allows for maximum use of light, which is both environmentally sound and also thought to be beneficial in the healing of patients."[129] Intended to combine Arabic and modern architecture, the hospital interiors were redesigned by the Hamad Medical Corporation (HMC), the primary nonprofit healthcare provider for the State of Qatar. An Egyptian subconsultant was also involved in the design of the project, perhaps explaining the rather colorful design.

The construction, completion, and maintenance of the project were supervised by the Public Works Authority (ASHGAL). ASHGAL was established on the basis of the Emiri Decree No. 1, issued by His Highness the Emir on January 20, 2004, as "an autonomous body to oversee all infrastructure related projects as well as public amenities of the State."[130]

The main hospital building, the largest healthcare facility in the country, has six floors and an area of about 88,100 square meters (948,300 square feet). Ancillary buildings with a total area of about 15,300 square meters (164,688 square feet) include stores, workshops, a medical-waste treatment building, and technical structures as well as a 25,000-square-meter (269,100-square-feet) four-story car park with 620 spaces. The total built area of the project is approximately 128,400 square meters (1,382,100 square feet).[131] The main contractor was J&P (Joannou & Paraskevaides Overseas Limited), a worldwide group with 20,000 employees established in 1961.[132]

Heart Hospital

Almana Design Consultants Intl, 2011

Heart Hospital is part of the Hamad bin Khalifa Medical City campus. Almana Design Consultants International (ADCI-Doha) undertook the architectural design. ASHGHAL and the Hamad Medical Corporation (HMC) managed the project. ASHGHAL formally handed over responsibility for the structure to HMC in 2010, although its basic form was completed as early as 2007. Modifications after that date were made to achieve the standards of healthcare that HMC was pursuing. Heart Hospital is situated near Rumaillah Hospital and has a floor area of 25,500 square meters (274,480 square feet) and a staff of 350 persons. It is connected to the National Center for Cancer Care and Research via a corridor. Hospital capacity is about 116 beds, divided between inpatient and temporary rooms, intensive care, and other departments. Almana Design was given responsibility for the design, construction, completion, and maintenance of the three-story building, complete with all services and external works.

The project consisted in the demolition of existing buildings and the construction and maintenance of Heart Hospital's main and ancillary buildings. The buildings were built using reinforced concrete.[133] Although some references to local architecture are made in the external forms of the completed building, the main focus of the design is of course on its medical function. Almana Design Consultants International is a Qatari multidisciplinary practice (architectural, structural, mechanical, air conditioning, electrical, and public health) established in 1974 by Abdulla Khalid Almana.

Al Khor Hospital

RJ Harris, 2005

Serving the 125,000 persons in Qatar's north, Al Khor Hospital opened on February 27, 2005. The architectural design was handled by RJ Harris (Qatar). The hospital has 115 beds, including 10 for pediatrics. The facility offers general medical care, general surgery, emergency medicine, obstetrics, pediatrics, and neonatal care. Al Khor Hospital, which is JCI accredited, also has eight state-of-the-art wings for surgical operations, ready to handle different cases. The hospital envisages increasing the number of beds to 200 as part of an expansion plan that also includes building accommodations for female nurses. "We are confident that as part of HMC's decentraliza-

National Center for Cancer Care & Research

tion process for each hospital, we will be able to build upon our unique brand of healthcare at AKH, which would be recognized and emulated," says Mohamed Al Jusaiman, the executive director of the hospital. In May 2011, the minister of public health and secretary general of the Supreme Council for Health, HE Abdullah bin Khalid al-Qahtani, opened the Nasser bin Abdullah al-Misnad Dialysis Center and Aisha al-Misnad Children's Emergency Center at Al Khor Hospital.

Qatari Engineers & Associates (QEA), 2003
Formerly called Al Amal Hospital, the National Center for Cancer Care and Research (NCCCR) is located in the Rumaillah Hospital compound in Hamad bin Khalifa Medical City. It is a two-story reinforced concrete framed structure with a radiology bunker on part of the ground floor. The architectural consultants for the 15,484-square-meter (166,668-square-foot) facility were Qatari Engineers & Associates. MIDMAC was the main contractor for the project carried out between 2001 and 2003. Specializing in cancer care (oncology), the facility collaborates with the University of Heidelberg in Germany. An extension to the inpatient ward added one floor to the existing building.[134] The NCCCR provides not only radiotherapy but also physical and psychological therapy. State-of-the-art systems such as RapidArc technology are used for the radiotherapy. RapidArc enables clinicians to deliver a highly precise image-guided intensity-modulated radiotherapy treatment in as little as one or two revolutions of the machine around the patient, much faster than is possible with conventional IMRT.[135] In 2011 the Department of Radiation Oncology at NCCCR was declared a "center of competence" by the International Atomic Energy Agency (IAEA) under its Quality Assurance in Radiation Oncology program.[136] It was also in that year that HH Sheikha Moza bint Nasser proposed that the name of the hospital be changed in connection with recommendations of the National Cancer Strategy. At that time, plans to refurbish and further enlarge Al Amal Hospital were also made.[137] There are also plans to create an urban plaza linking the four main hospitals of the complex, with ongoing plans reaching forward to 2018.

ASPETAR Qatar Orthopedic & Sports Medicine Hospital

Ellerbe Becket, 2006

Ellerbe Becket, an AECOM company, designed the ASPETAR Qatar Orthopedic and Sports Medicine Hospital to "create a new paradigm in healthcare planning. Its focus on efficiency, flexibility, and the development of a healing environment makes it the premier orthopedic and sports medicine facility in the region."[138]

ASPETAR is the first specialized orthopedic and sports medicine hospital in the Gulf region.[139] It provides a full range of services, from injury prevention to injury management and performance improvement. Clearly it is at the higher end of sports medicine facilities anywhere in the world, and "the philosophy of ASPETAR is to provide sportspeople with the clinical support, knowledge and facilities to maximize their training and competitive potential. This is achieved through tailored education programs and support in areas of health including fitness assessment, nutrition, psychology, physiology and physical training."[140] The 17,600-square-meter (189,444-square-foot) facility accepted its first patient, aside from the Asian Games, on April 15, 2007, and has treated more than 35,000 athletes as of 2011, when the Arab Games were held in Doha. ASPETAR contains emergency, radiology, and operating rooms, 50 patient beds, rehabilitation services, a gymnasium and running track, an outpatient clinic, and areas dedicated to thalassotherapy, sports enhancement, and testing. The VIP suites for inpatients have been compared to an "upscale hospitality environment including room service dining, relaxation areas, exercise and leisure areas."[141] Ellerbe Becket was awarded the commission for ASPETAR in May 2003 and completed the initial design just three months later. The goal of the architects and the client was to have the facility operational for the 2006 Asian Games, held in Doha and based in the Aspire Zone. In terms of its architecture, ASPETAR immediately makes clear its modern approach. Set close to Khalifa Stadium and a sports field, it continually gives an impression of an open dialogue with its environment, quite the opposite of many healthcare facilities. The entire project seeks and finds a balance between a certain architectural dynamism and the kind of solidity and predictability that one expects of an excellent medical facility. Generous ceiling heights and corridor width make visitors and patients feel very much at ease. Part of this architectural environment has to do with giving injured athletes the feeling that they are on the road to recovery as they look out at active sports facilities. Cantilevered canopies and carefully studied sun shading are part of the strategy to adapt ASPETAR to the climate of Qatar.

The New Emiri Diwan

Rader Mileto and Batori et al, 1972–89

Recently restored by the Private Engineering Office, the New Emiri Diwan is located on the Corniche. *Featured on page 114.*

Qatar Science & Technology Park

Woods Bagot, 2010
Located behind the National Convention Center at Education City, this facility encourages all types of technical innovation.
Featured on page 162.

Qatar National Convention Center

Arata Isozaki, 2011
A main façade on the Dukhan Highway at Education City is marked by a stylized Sidra tree, symbol of the Qatar Foundation.
Featured on page 90.

Ministry of Finance

Kenzo Tange & Urtec, 1984
One of the first major buildings in Doha by an internationally recognized architect, located near the Museum of Islamic Art.
Featured on page 222.

The Rise of Doha

Msheireb Downtown

Phase 1A Allies & Morrison, 2012
This project, part of a larger development, consists of a complex of buildings for the Emiri Diwan Amiri (Diwan Annex, Emiri Guards' barracks, and the Qatar National Archive), four heritage buildings: the Bin Jalmood House, Company House, Mohamed Bin Jassim House, and Al Radwani House, all of which have been restored and are being turned into museums. The overall project, including its four future phases, will cover 31 hectares (77 acres) located behind the Emiri Diwan, near the Souq Waqif and partially along Al Rayyan Road to the north. There could hardly be a more central site with respect to the history of the city. The master development consultants were Arup, AECOM (formerly EDAW), and Allies & Morrison. The site-wide "architectural language consultants" are Allies & Morrison, and in particular Tim Makower, lead partner on the project with Allies & Morrison and now architectural language advisor for Msheireb Properties.

Other architects have already been selected for future phases, including David Adjaye, Mossessian & Partners, John McAslan, and HOK (the full list is much longer). The overall aim of the scheme is to "regenerate and renew the historical downtown of Doha." The developer, Msheireb Properties, states, "The Msheireb Downtown project will blend traditional Qatari heritage and aesthetics with modern technology, and focus on sustainability and harmony with the environment. The aim of the project is to bring people back to their roots—to make Doha unique and rediscover a sense of community and togetherness."[142] Msheireb Properties is a real estate company and a subsidiary of Qatar Foundation. The company was established as a commercial venture to support the foundation's aims and Qatar National Vision 2030.[143] The impetus for the project came from Her Highness Sheikha Moza bint Nasser, chairperson of the Qatar Foundation, who has spoken of "looking to the future while being rooted in the past."

From the time of the original master plan, such elements as local climate were taken into account, seeking, for example, to maximize shaded areas and to take advantage of prevailing winds. Concern for the environment goes much further here than in most new developments in the region. The entire development is aiming for an average gold rating under the LEED (Leadership in Energy and Environmental Design) certification system developed by the U.S. Green Building Council (USGBC), with several structures intending to obtain a platinum rating.

In terms of the architectural designs, Allies & Morrison has encouraged other architects participating in the overall project to follow a set of guidelines, including "a richly variegated but cohesive street frontage." Although the Msheireb complex is large, it will contain "urban townhouses" inspired by traditional Qatari courtyard houses. Referring to the main elements of Phase 1A, Makower states, "Each building is rooted in a particular Qatari archetype: the fortified tower for the National Archive: the fort and courtyard dwelling for the Emiri Guards' HQ; and the *liwan*-encased small palace *(diwania)* for the Diwan Annex. They act as a family of buildings, all related, but each one is seen as an individual."[144]

From the outset, Msheireb was based on the vision of Her Highness Sheikha Moza bint Nasser to breathe life back into the city center and to encourage Qatari families to live there again. The medium-density, mixed-use formula chosen for Msheireb means that schools, shops, and places to work and live are all nearby, and that a car is not indispensable for moving about. The architect speaks here of a "lifestyle innovation," where supply leads demand, offering "a new, sustainable lifestyle within the city." Makower concludes, "The image of the tree has underpinned our thoughts. The roots run deep, to a large extent unseen; meanwhile the new growth flourishes; both are connected, and so it is a continuum."

The Pearl-Qatar

Callison, 2011– ongoing

The Pearl-Qatar is located on a 400-hectare (988-acre) artificial island at West Bay Lagoon and is due to accommodate a total of 40,000 residents on completion.[145] The island, connected to the mainland by a causeway, was created by dredging and filling the offshore site to an elevation of approximately 3 meters (9.8 feet) above mean sea level. The island's shoreline is stabilized by seawalls and beaches made with marine sand. This was Qatar's first international real estate venture and first to offer freehold and residential rights to foreigners. Three marinas for 1,000 boats are planned, as are no less than 2 million square meters (21.5 million square feet) of retail space. As of the spring of 2012, the Pearl-Qatar had 5,000 residents. The architectural style of the Pearl has been described as "Mediterranean from Spain and the Middle East."[146] According to the developer's description, visitors and clients will discover "the atmosphere of the Riviera within the warm waters of the Arabian Gulf. A rediscovered island off the coast of one of the world's most rapidly expanding economies. An investment in a place of outstanding beauty and cosmopolitan charm. This is The Pearl-Qatar, an island, which will redefine an entire nation; a destination of qualities that are unique in the region."[147]

The development is divided into several districts called the Quartiers, Costa Malaz, Porto Arabia, Viva Bahriya, La Plage Villas, Bahri Villas, and Isola Dana, each of which has different participants in the design and development process. The Mediterranean theming of the architecture is intended to tie the complex together, although its vast size and ambition mean that many different architects, mostly from very large international firms, will have participated in the design process. Callison was the Pearl's main architect and master planner, while Dar Al Handasah was the project and construction manager. It cannot be said that cutting-edge architecture is involved here, but the scale and goals of the project are such that a more easily acceptable "Mediterranean" style was deemed the most appropriate solution. This is an investment development vehicle that provides luxurious surroundings for its clients.

The overall client for the project, which is located 12 kilometers (7.5 miles) from the former Doha International Airport, is the United Development Company PSC (UDC), established in 1999 and listed on the Qatar Exchange since 2003. UDC's "target areas of interest include: infrastructure, energy-intensive industries, hydrocarbon downstream manufacturing, real estate, maritime and environment-related businesses, urban development and utilities, hospitality, retail and fashion, information technology, media and communications, insurance and other services."[148]

General Post Office

Twist + Whitley Architects, 1982

The General Post Office is one of the most visible older buildings in Doha. It is located close to the bay on a site between the Corniche and Majlis Al Taawon Street, near the towers of West Bay and not far from the Qatar National Theater.[149] Designed in 1979 by the British firm Twist + Whitley Architects, the roof of the building assumes the form of a pigeon loft, a reference to traditional methods of sending messages. The structural engineer for the building was Bingham Blades. One of the first buildings to be erected in the New District of Doha (NDOD), the General Post Office contains no fewer than 25,000 electronically operated post office boxes as well as all other public postal services.

Post office boxes assumed an important function for many residents of Doha, in part because of the lack of specific street addresses but also because there is no regular delivery service to residences.[150] Parking for 600 cars is arrayed in covered areas that are above ground but beneath the main five-story structure. It is possible to drive up from street level through the car park to the main entrance of the building, an unusual configuration that emphasizes the importance of car transport in Doha. This design takes into account the needs of large numbers of box holders to access their mail each day. The semimonocoque roof units serve to shelter the interior from the sun while allowing natural light into the structure. The interior spaces, which include small shops or cafés, have a shaded character, with natural overhead light admitted through the "pigeon holes" of the roof. This atmosphere might bring to mind certain regional markets or souks, were it not for the massive arrays of P.O. boxes that greet the visitor.

A postal vehicle workshop is also part of the complex, which was officially inaugurated only in 1988. Q-Post today recalls that "the building was a noble dream of Qatar Post founder, the late Mr. Mohammed Bin Saif Al-Moadhadi, and it lived in his mind until his dream came true."[151] The Post Office itself emphasizes that its operations began within living memory (1950) with a staff at the time of just six persons. In May 1963, the State of Qatar took full responsibility for postal services.[152] There are now 27 postal branches in the country, of which 18 have P.O. boxes. Although this relieves pressure on the central facility somewhat, this building, visibly dating from the early 1980s, remains a focus in Doha because of its location, its architecture, and the ongoing heavy use that it engenders. In order to adapt itself to a changing environment, the General Postal Corporation (GPC) became an independent corporation in October 2011.

Since there are no tall buildings in its immediate vicinity, the General Post Office is still visible from a considerable distance. It location was selected from the outset as part of the civic and cultural zone of the Corniche, underlining the symbolic and architectural importance of the building to the State of Qatar. Because the rectangular building has a rather low profile (total height 63.5 meters, or 208.3 feet)[153], its mass is not immediately evident, but it does have a total floor area of 33,540 square meters (361,022 square feet).[154] It is interesting to note that whereas some other early buildings in Doha, such as Kenzo Tange's Ministry of Finance, did not necessarily refer to local tradition, the General Post Office, with its pigeon-loft theme, represents a conscious attempt to tie a modern building into the history of the country and the region. This could hardly be called historicism since there is a substantial scale shift as well as a change in the mode of function that separate this building from the past, but the General Post Office remains an interesting study of how best to respect local culture and tradition in a new era. With its social atmosphere where crowds mingle, this structure also perpetuates a sense of community, a rarity in a world that seems to be quickly going the way of the Internet.

Grand Hyatt Hotel

GHD+HBA/Hirsch Bedner Associates, 2009
GHD was the principal consultant for the design of this five-star tourist resort. The Grand Hyatt was commissioned by the Tourism Investment Company, and GHD was engaged by HE Shekh Falah bin Jassim Al Thani, the former minister of civil service affairs and housing, for the design and supervision of the architecture, structure, and landscape of this hotel. The designers state, "The architecture and services are designed in modern Qatari style and provide a solution to the harsh desert environment. . . . The innovative cluster layout concept maximizes the view of the beach from each villa, while retaining privacy. The design engenders the site's characteristics, that of the collusion of water and the desert."[155] There are 249 rooms, including nearly 40 suites. Nine four-bedroom three-floor beachfront villas with a maid's room are among the suite arrangements available.[156] The Global Hyatt Corporation compared public areas of the hotel to the "inner courts of the Emir's Palace," in a 2008 news release.[157] Indeed, the main arched façade of the facility, with its twin towers that are somewhat reminiscent of Middle Eastern wind towers albeit on a larger scale, brings to mind a rather grand palace more than a hotel. The Grand Hyatt also provides a total of 2,200 square meters (23,680 square feet) of function space on two floors. A 1,500-square-meter (16,146-square-foot) column-free ballroom, 8 meeting rooms, and 3 boardrooms complete the conference center. The Grand Hyatt was built on a 15.5-hectare (38.3-acre) site on the shore of West Bay Lagoon, near the Pearl and not far from Katara Cultural Village on one side and the so-called Zig-Zag Towers leading to Lusail City on the other.

The architecture of the Grand Hyatt complex was described as "arabesque . . . with its old-world design" in 2009 by the local newspaper *The Gulf Times*, but it also has a Thai restaurant and an "Australian-style grill," emphasizing the inevitably cosmopolitan nature of such tourist resort hotels. The vast lobby space, with its extremely high ceilings and 17- meter- (56-foot-) tall windows, immediately announces the luxury of the establishment. A star-shaped fountain and geometric decorative patterns naturally recall Islamic decorative arts without plunging headlong into historicist postmodern-style design. On the occasion of the opening in 2009, the Reuters release read, "The property's locally inspired interior architecture re-creates the traditional elegance of an Arabian palace with palatial entryways and public spaces. . . . Qatari-based artist Nijenbandring de Boer has been commissioned to produce paintings inspired by local

scenery and traditional art, which are featured prominently in the hotel."[158] In fact, the artist Linda Nijenbandring de Boer was asked to create a total of 260 paintings, which are displayed throughout the hotel and residences.[159] The level of luxury and the quality of the architecture and design expected by clients are obviously high in the case of such establishments. Though five-star hotels as a genre are not easy to specifically relate to historic Qatari or Gulf architecture, a reasonable attempt has been made here to bridge the gap between the imagined past and the rapidly changing future. As much as government institutions may seek to support and highlight Qatari architecture and traditions, the public face of the country is also formed by privately controlled hotels such as the Doha Grand Hyatt. Clearly, an effort to evoke regional forms has been made, surely a far better solution than the many glass cubes seen elsewhere along the shores of the Gulf.

Doha Tower

Ateliers Jean Nouvel, 2011
In the heart of West Bay, the first major work in Qatar by Jean Nouvel, who is also the designer of the future National Museum of Qatar. *Featured on page 100.*

Tornado Tower

JSK SIAT International, CICO Consulting Architects & Engineers, 2009
Also in West Bay, just behind the Doha Tower, this 52-story structure has a round floor plan, with a rhomboid shape in section. *Featured on page 172.*

Al Sharq Village & Spa

Ibrahim Al-Jaidah & Rula Habamala, 2008
Located very close to the runways of the former Doha International Airport at the end of the Corniche, the Al Sharq Village and Spa was designed by the Arab Engineering Bureau for the Qatar National Hotels Company (now called Katara Hospitality).[160] It is managed by Ritz-Carlton, and the interior design was the work of Dileonardo International. The landscaping of the 95,000-square-meter (1,022,572-square-foot) site was by Khatib & Cracknell. The 5,200-square-meter (55,972-square-foot) complex received the Arab Towns Organization Award (2008). The architects explain that their idea was to follow "the vernacular style of sturdy rough exteriors awash with cool earth tones, articulated with rhythmic recesses . . . as well as rich interiors with palette of . . . hues and fabrics."[161]

The design of the Al Sharq Village and Spa, they continue, "re-creates . . . a traditional Qatari environment. The layout of this unique resort," they conclude, "gives impression of a typical Qatari sea side village that has grown organically over time." Rather than a single building, Al Sharq Village is made up of 14 *beits*, or "typical Qatari villas," with a central courtyard intended in the ideal for social interaction. In any case, these spaces, with small fountains and trees, offer welcome respite from the sun. There are 174 rooms decorated in a traditional style in these villas. A royal suite contains a private pool and gym as well as five bedrooms and a *majlis*. The lobby of the hotel, its main restaurant, and bar are situated near a large outdoor swimming pool, around which some of the villas are located. Other villas face a generous beach and, in the distance, the towers of West Bay. Clients reach their rooms by walking along the landscaped pathways that rarely allow for a straight-line progression. Water features in the gardens near the villas provide a refreshing sound in the warm months of summer.

Further external courtyards and a multitude of smaller water features made up of various pools and small fountains create a tranquil ambience and entice the visitor's eye to travel through the paths and lanes of the village. Careful attention was paid to interior detailing, with heavy wooden doors and traditional plastering methods. As the architects put it, "Traditional Qatari construction methods were imitated at Al Sharq so that past is seen in the very structure itself."[162] Travelers arriving from the airport easily spot the crenellated exterior walls of the hotel, which was recently repainted in white to more closely match the older architecture of Qatar.

Hamad International Airport

Bechtel, HOK, ADPI, et al., 2012
Opened to air traffic in 2014, Hamad International Airport offers capacity for at least 24 million passengers a year.
Featured on page 126.

Sheraton Doha Hotel

William L. Pereira, 1982
Opposite the towers of West Bay, another of the celebrated early modern structures of Doha with a 13-story central atrium.
Featured on page 188.

Educational Projects

The Awsaj Institute

James Cubitt, 2011

Founded in 1996, and formerly known as the Learning Center, the Awsaj Institute is located at the western extremity of the Education City campus core.[163] It is visible from the Dukhan Highway and is set not far from the buildings of the Qatar Academy. James Cubitt & Partners designed the building. The contractor for the new building, inaugurated in September 2011, was Al Jaber Trading, with project management under the control of the Qatar Foundation Capital Projects Directorate, Qatar Petroleum Onshore Engineering Department, and KEO International.

The airy, bright 19,000-square-meter (204,514-square-foot) facility houses an educational program that provides assistance to students who experience academic difficulties. Ranging in age from kindergarten to twelfth grade, students are taught in regular classroom settings but are given individual attention. Every student is given an Alternative Education Plan (AEP) designed to set goals and measure progress throughout the year. Teaching is in English, and the curriculum includes math, English, social studies, science, Arabic, Islamic studies, art, IT, and physical education. The Awsaj Institute also has professional development and outreach services for teachers and education professionals in Qatar and beyond. The school was named after the hearty *awsaj*, a rigid, thorny plant native to Qatar that grows to a height of 3 meters (9.8 feet) and flowers throughout the year, bearing edible red berries.

The institute has at least three readily identifiable volumes, including a large sports facility on the west that is divided from the classroom blocks by a generous green space. With a 50-meter (164-foot) swimming pool, a large indoor space for basketball or similar sports, a running track, and a football field, this element of the Awsaj Institute is of particularly generous dimensions. The main school blocks contain classrooms, computer and science labs, and spaces for art, drama, and music. Shaded outdoor courtyards formed between the classroom building's volumes are used in cooler weather for play or teaching. Glazing is extensive, contributing to the bright aspect of the school interiors. Other exterior claddings are often beige, in keeping with a stylized conception of local architecture. Cafeterias, a 400-seat auditorium, and a library are also part of the Awsaj Institute. In elevation, the main part of the institute is essentially a long, low building with elements differentiated more by façade treatments than by height. Seen in plan, the building has two main areas, one arrayed to either side of the auditorium, and to either side of a round fountain courtyard on the other. The first of these fully connected blocks follows a largely symmetric design on either side of the auditorium, whereas the second is rotated by about 15 degrees vis-à-vis the first.

Weill Cornell Medical College

Arata Isozaki & i-Net, 2003
One of the first major new buildings completed at Education City by Arata Isozaki, author of the original master plan for the complex. *Featured on page 48.*

Ceremonial Court

Arata Isozaki & i-Net, 2007
Located at one end of the Ceremonial Green Spine at Education City, opposite the Qatar National Convention Center. *Featured on page 60.*

Liberal Arts & Science Building

Arata Isozaki & i-Net, Cat, 2004
Local traditional architecture and very modern quasicrystals inspired this facility at Education City. *Featured on page 80.*

College of the North Atlantic

Woods Bagot, 2005

This institution began its operation in Qatar in September 2002 through an agreement between the State of Qatar and the College of the North Atlantic, which is based in Newfoundland and Labrador, Canada. The College of the North Atlantic–Qatar, designed by Woods Bagot, was completed in November 2005 and formally opened by Her Highness Sheikha Moza bint Nasser on December 1 of that year. The project manager for this complex was KEO Doha, and the contractor was United Engineers (Malaysia) Berhad. The school offers programs in health sciences, information technology, engineering technology, and business studies; it has a staff of more than 650 persons and counts approximately 4,600 full- and part-time students. The focus of the institution is on training professionals for careers in the oil and gas industries. The campus has a total floor area of 75,000 square meters (807,293 square feet) in 20 buildings. There are 10 principal courtyards of varying sizes and character providing links for pedestrian movement between buildings, for events, and as student and staff gathering places. Containing more than 70 computer labs, the complex has dedicated buildings for each program area. Male and female students have separate cafeterias, student lounges, and recreational areas with swimming pools. Common spaces include public lobbies, cafés, libraries, classrooms, laboratories, auditoriums (including one that seats 500), and courtyards. The college states, "Traditional elements and modern design have merged in a unique architectural concept. The campus provides a friendly and comfortable environment that is conducive to study, learning and communication, and delivers an exterior and interior design that is memorable and worthy of the institution."[164]

The architects who collaborated closely with the College of the North Atlantic in Canada state, "There was a strong desire for this project to express both the country's cultural heritage and an architecture contributing to an emerging regional, whilst distinctly modern, Qatar. To this end, research for the project focused upon the urban heritage of Doha, the capital city, and the rich distinctive designs of its textile artifacts and Arabic scripts."[165] The patterns of paths within the campus thus are inspired by the streets of old Doha.

American School of Doha

GHD, 2009

The American School of Doha (ASD) was founded in 1988 by U.S. ambassador Joseph Ghougassian to serve the needs of the American community in Qatar. At the time, a villa housed the school, which consisted in lower-elementary classes and a small teaching staff recruited from the local community. Called the American International School (AIS) at the time, the institution moved in 1989 to its Old Rayyan campus, a purpose-built Arabic school owned by a member of the Qatari ruling family. The present campus is located 8.6 kilometers (5.3 miles) southwest of the Museum of Islamic Art and the Corniche, near the Salwa Road and next to Jassim Bin Hamad Stadium.[166] Grade levels were added progressively and American teachers were recruited. In the mid-1990s, numerous American firms increased their activities in Qatar, and the school inevitably faced more demand. The library was expanded in 1994, and two neighboring villas were rented to create the AIS Language Center. By 1995, a full high school program had been introduced to the school. With support from various corporations, work on the new school began on December 14, 1996, and was completed in November of the following year. In 1997, the school was renamed American School of Doha (ASD). A library, two music rooms, biology, chemistry and physics laboratories, two art labs, a full-size gymnasium (indoor), outdoor basketball and volleyball courts, two tennis courts, a soccer field, and a 25-meter- (82-foot-) outdoor swimming pool were added to the campus. At the time, the campus had an area of 3.2 hectares (8 acres).[167] With enrollment reaching 600 students in 2004, further expansion was envisioned thanks to a gift from the Emir of an adjoining site formerly used for parking. An architectural consultation was organized, with 35 firms participating.[168] The school committee selected Hillier Architects, founded by J. Robert Hillier in 1966 in Princeton, New Jersey. Hillier became part of the larger architectural firm RMJM in 2007.

By early 2005, plans were drawn up for the expansion, and the Doha firm Al Sraiya was selected as the main contractor. Hill International was the project manager, with the Arab Engineering Bureau (AEB) acting as a local representative office. Construction took place between June 2005 and the fall of 2007. The scheme consisted in creating a new middle and high school and the conversion of the existing campus into the elementary school, completed in 2009. As the ASD describes the new facilities, "There was a double gym, a fitness center, an indoor pool, and a theater that could seat 635 students. The middle school was a separate building with an individual floor for each grade level, while the high school was arranged according to individual disciplines. Both schools were served by a large, modern library as well as a spacious dining hall. The school also had a full sized soccer pitch and a 400-meter track."[169]

The completed facility consists of 42,736 square meters (460,006 square feet) of new and renovated spaces. The architects state, the "resulting composition is a campus of interlocking courtyards and playing fields featuring a distinct identity for each complex. This solution helps break down the large student population into more manageable groups. Four distinct 'centers' are created: two for the elementary school (lower and upper elementary), along with one each for the middle and high school. The design promotes best pedagogical practices and ad-hoc social interaction by avoiding the formulaic hallway and boxy classrooms typical of older schools. Interaction between teachers and students is actively encouraged through the extensive use of glass while communal planning and meeting spaces replace the traditional private office."[170]

Georgetown University School of Foreign Service

Legorreta+Legorreta, 2010
A 40,000-square-meter (430,556-square foot) building at Education City for a leading school of international studies.
Featured on page 256.

Texas A&M University

Legorreta+Legorreta, 2008
The first of four buildings at Education City designed by the noted Mexican architect Ricardo Legorreta. *Featured on page 212.*

Carnegie Mellon University in Qatar

Legorreta+Legorreta, 2008
Located between Weill Cornell Medical College in Qatar and Texas A&M University at Qatar in Education City.
Featured on page 202.

Qatar University

Kamal El-Kafrawi, 1985

600 concrete octagons form the faculty buildings and library of this university located 16 kilometers (10 miles) from the center of Doha. *Featured on page 236.*

Student Center

Legorreta+Legorreta, 2010

The fourth and final building by Ricardo Legorreta on the Education City Campus, intended for use by 10,000 students. *Featured on page 194.*

Sports Facilities

Losail International Circuit

MIDMAC, 2004

The Losail International Circuit, dedicated in large part to motorcycle racing, is located about 20 kilometers (12.4 miles) from the center of Doha and was built in just over one year, opening with the Marlboro Grand Prix of Qatar on October 2, 2004.[171] The construction required the participation of 1,000 workers on a round-the-clock schedule.[172] The circuit, designed by Mick Doohan, the former Grand Prix motorcycle road-racing world champion is 12 meters (39 feet) wide and 5.38 kilometers (3.34 miles) long.[173] It is surrounded by artificial grass to avoid excessive accumulation of sand on the track. Doohan, an Australian, won five consecutive 500cc world championships (1994–98).

The Doha firm CICO Consulting Engineers designed the Losail International Circuit buildings for the Qatar Motor & Motor Cycle Federation. CICO was also involved in the design of the Qatar National Theater and Ministry of Information, as well as the Tornado Tower. The site area of the Losail Circuit is a generous 3.6 square kilometers (1.4 square miles). The built-up area includes 50,000 square meters (538,196 square feet) for the paddocks, and 15,000 square meters (161,459 square feet) for associated buildings including the control tower, medical center, pit boxes, media center, and VIP Village. The grandstands are fully modern, and there is public parking for 2,000 cars on site.[174] The main contractor for the circuit was Contraco, with MIDMAC as EPC (engineering, procurement, and construction) subcontractor. It is interesting to note that all three major firms involved in the design and construction of the Losail International Circuit are Qatari. Though it is located in the Al Lusail area, the name of the circuit is spelled with an "o."

The Losail Circuit was the venue of the first nighttime motorcycle Grand Prix, in 2008. Losail is the only circuit in the region with both FIA (Fédération Internationale de l'Automobile) and FIM (Fédération Internationale de Motocyclisme) homologation licenses. It has 40 pit garages, 82 team offices, two 900-square-meter (9,688-square-foot) VIP areas, and a pressroom for 200 journalists.[175] The main grandstand, seating 5,000 spectators, is located just opposite the pit garages, giving spectators a perfect view of transpiring events, from start to finish.

Aspire Zone

Cox Architecture, PTW, Roger Taillibert, CICO, 2005

Sports facilities including the 50,000-seat Khalifa Stadium and the Aspire Academy with its signature dome designed by Roger Taillibert. *Featured on page 142.*

Aspire Tower

Hadi Simaan, 2006

A 300-meter-high tower including a hotel that marks the site of the Aspire Zone and its associated areas outside of Doha. *Featured on page 142.*

Al Shaqab

Leigh & Orange, 2011

A world-class equestrian facility including indoor and outdoor arenas as well as paddocks and training areas. *Featured on page 154.*

Doha Golf Club

Peter Harradine, 1997

Doha Golf Club has a 7,312-yard 18-hole championship course and a floodlit 9-hole academy, or "executive," course for less-experienced golfers. The Club's Golf Academy is a teaching and practice facility with a driving range and chipping, putting, and bunker practice areas. There are eight artificial lakes on the course, which is dominated by an "Arabian-style" clubhouse. The 150-hectare (371-acre) site was planted with 5,000 shrubs and 6,000 trees, including 1,300 palm trees and 10,000 cacti imported from Arizona, about 65 of which are of the giant Saguaro variety.[176] Natural outcrops of eroded rock are included in the course. The clubhouse, designed to evoke a Qatari residence, also has Arabian-style interiors, with fountains and large areas covered in marble. The solid teak doors were imported from Thailand and carved in Doha. The interior of the clubhouse is relatively intimate in scale but includes bars and restaurants with outdoor terraces overlooking the course, as well as a pro shop.

Peter Harradine designed the course in 1994. Harradine, a third-generation golf course designer, was born in 1945 in Bern, Switzerland. He is the chief architect of Harradine Golf and has designed and codesigned over 180 golf courses in Europe, Africa, the Middle East, and Asia.[177] The Doha Golf Club was the first grass course created in Qatar. The Qatar Golf Association indicates that the first course created in the country was built in 1949 in Dukhan by the Iraq Petroleum Company.[178] Voted number two in the Middle East by *Golf Digest* (2009), the Doha Golf Club saw its fifteenth hole elected best-designed hole in the Middle East (2008).[179] The top event held at the Doha Golf Club since 1998 is the Qatar Masters, which attracts some of the best golfers from the European tour. The club is open to golfers who are members and to playing nonmembers. Approximately 320 golfers use it on a regular basis. There is an active membership of 600 and a waiting list of 100. The clubhouse was built in 1994–95, and the golf club, located near West Bay Lagoon, 8 kilometers (5 miles) north of the city center, opened in 1997. The design architect was Samir Daoud (Diar Consult). Diar Consult was the winner of an invited international design competition organized by the Ministry of Municipal Affairs and Agriculture, Building Projects Department, which was headed at that time by Ibrahim Al Jaidah (now principal of AEB in Doha). According to Peter Ellis, "The architectural style was largely guided by Ibrahim Jaidah."[180] The lead consultant for the project was Rice Perry Ellis (RPE), which in this instance means that the firm was responsible for the design coordination and the supervision of the construction. The club was originally owned by Qatar National Hotels Company (now called Katara Hospitality). The contractor for the project was Hamad Bin Khalid Contracting. The rather lush greenery of the Doha Golf Club is definitely a contrast to the neighboring desert landscape. Prior to the intervention of Peter Harradine, the site of the course was indeed desert. Architecturally speaking, the clubhouse is of interest as a compromise between regional residential designs and the requirements of a modern golf club. The entrance-side façade, with visibly raised "rampart" corners that immediately evoke the "Arabian" theme, is fairly closed and white, whereas the golf course side immediately opposite is more open, allowing some views to the course, in particular from the sheltered terraces.

Notes

1. The author visited the construction site of the MIA on several occasions and attended the opening in 2008. He is also the author of *Doha Museum of Islamic Art, Doha, Qatar* (Munich, Ger.: Qatar Museums Authority, Prestel Verlag, 2008).
2. I. M. Pei, in discussion with the author, New York, March 23, 2006.
3. Ibid.
4. Ibid.
5. Jean-Michel Wilmotte, in discussion with the author, Paris, December 15, 2006.
6. MIAP_Timeline_credits. Pei Partnership Architects, October 29, 2011.
7. "MIA opens Park to public on Friday," *The Penninsula*, January 4, 2012. Accessed July 12, 2012, http://www.thepeninsulaqatar.com/qatar/178292-mia-opens-park-to-public-on-friday.html
8. "Mas'ud III ke Minar," ArchNet Digital Library. Accessed July 13, 2012, http://archnet.org/library/sites/one-site.jsp?site_id=10541.
9. "The magnificent '7' adds an edge to Doha's gloss," *The Independent*, December 28, 2011. Accessed July 13, 2012, http://www.independent.co.uk/arts-entertainment/architecture/the-magnificent-7-adds-an-edge-to-dohas-gloss-6281994.html.
10. Ibid.
11. "Tomorrow's technology for the day after tomorrow: Stadia and infrastructure for the 2022 World Cup in Qatar," Plastruction, March/April 2011, p. 13. Accessed July 13, 2012, https://www.hbmedia.info/plastruction/assets/ebooks/PT201103.oiewndcqb43/files/pt201103.pdf.
12. The author visited Weill Cornell Medical College on November 24, 2010.
13. Quotes from *Weill Cornell Qatar Chronicle*, 1(4), December 2003. Accessed July 3, 2012, http://qatar-weill.cornell.edu/media/chronicle/pdfs/qatarChronicle_v1_n4.pdf.
14. The author visited the Ceremonial Court on November 24, 2010.
15. "State Mosque to be named after Imam Abdul Wahhab," *Gulf Times*, December 14, 2011. Accessed July 15, 2012, http://gulftimes.com/site/topics/article.asp?cu_no=2&item_no=475722&version=1&template_id=36&parent_id=16.
16. Mohamed Ali Abdullah, e-mail to the author, July 31, 2012.
17. Accessed July 15, 2012, http://www.qatartourism.gov.qa/pillars/index/1/culture/238.
18. Accessed July 15, 2012, http://catnaps.org/islamic/islaurb3.html#wah.
19. Mohamed Ali Abdullah, telephone conversation with the author, July 30, 2012
20. Accessed July 15, 2012, http://www.diwan.gov.qa/english/the_amir/the_amir_speeche_117.htm.
21. The author visited the Liberal Arts & Science building on November 24, 2010.
22. The author visited QNCC on September 25, 2011.
23. Accessed July 4, 2012, http://www.qatarconvention.com/site/en/Newsletters/The_Sidra_Signature.aspx.
24. Accessed July 10, 2012, http://www.isozakimaffei.it/ProjectDetails.aspx?IdProject=13.
25. CTBUH Nomination Form, Best Tall Building Award, April 30, 2012. Transmitted by the architects to the author, July 28, 2012.
26. "National Museum: Doha, Qatar, report by the Aga Khan Award for Architecture." Accessed September 14, 2012, http://www.akdn.org/architecture/pdf/0011_Qat.pdf
27. Salma Samar Damluji, *Al Diwan Al Amiria*, Doha, Qatar (London: Laurence King Publishing, 2011).
28. Florian Wiedmann, Ashraf M. Salama, Alain Thierstein, *Urban Evolution of the City of Doha: An Investigation into the Impact of Economic Transformations on Urban Structures*. Accessed July 21, 2012, jfa.arch.metu.edu.tr/archive/0258-5316/advop/35-61.pdf.
29. Samar Damluji, *Al Diwan Al Amiria*.
30. The author visited the Old Emiri Diwan on March 24, 2011.
31. Samar Damluji, *Al Diwan Al Amiria*.
32. Accessed July 21, 2012, http://www.catnaps.org/islamic/planning.html#dopal1.
33. Samar Damluji, *Al Diwan Al Amiria*.
34. Accessed September 14, 2012, http://catnaps.org/islamic/islaurb4.html.
35. Samar Damluji, *Al Diwan Al Amiria*.
36. The author visited the Ministry of Finance on May 17, 2012.
37. The author visited the New Doha International Airport on May 19, 2012.
38. Accessed July 24, 2012, http://www.bechtel.com/new_doha_airport.html.
39. Accessed July 24, 2012, http://www.ndiaproject.com/elements/7%20-%20Fascinating%20Facts.pdf.
40. "S.F. designers win airport work in Qatar: 'Eight-figure' deal," *San Francisco Business Times*. Accessed July 23, 2012, http://www.bizjournals.com/sanfrancisco/stories/2004/03/22/story6.html.

41. "Moly-grade stainless steel makes waves at Middle Eastern Airport," International Molybdenum Association. Accessed July 24, 2012, http://www.imoa.info/moly_uses/moly_grade_stainless_steels/architecture/doha_international_airport.php.
42. "Another airport contract for DCC in Doha, Qatar," *International Ropeway Review*. Accessed July 24, 2012, http://www.isr.at/Another-airport-contract-for-DCC.153+M52087573ab0.0.html.
43. Ali Moghaddasi, e-mail to the author, August 10, 2012.
44. Accessed July 23, 2012, http://www.ndiaproject.com/elements/9%20-%20Emiri%20Terminal.pdf
45. Accessed July 24, 2012, http://www.ghafari.com/content.cfm/middle-east.
46. Accessed July 20, 2012, http://www.coxarchitecture.com.au/#/project/11587.
47. Tristam Carfrae, Jane Nixon, Peter Macdonald (2006), "Khalifa Stadium, Doha, Qatar," *The Arup Journal* (2), pp. 44–50. Accessed July 21, 2012, www.arup.com/_assets/_download/download628.pdf.
48. 2022 FIFA World Cup Bid Evaluation Report: Qatar.
49. Accessed July 20, 2012, http://www.aspire.qa/Aboutus/OurHistory/Pages/OurHistory.aspx.
50. Accessed July 21, 2012, http://www.agencetaillibert.com/Ensemble_sportifs/Complexes_sportifs/Khalifa_Sport_City_Qatar.html.
51. "A sports paradise in the middle of the desert" [Press release], Alcoa Architectural Products. Accessed July 21, 2012, http://www.alcoa.com/aap/europe/en/news/releases/aap_aspire_dome.asp.
52. Accessed July 21, 2012, http://www.jtc-qa.com/html/cprojects.htm.
53. The author visited Al Shaqab Academy on September 25, 2011.
54. Accessed June 30, 2012, http://www.qf.org.qa/community-development/protecting-qatar-heritage/alshaqab/alshaqab.
55. Accessed July 10, 2012, http://www.alshaqab.com/about-us/interactive-map.
56. The author visited QSTP on September 25, 2011.
57. Accessed November 6, 2012, http://www.woodsbagot.com/en/Pages/QatarScienceTechnologyPark.aspx.
58. Accessed July 17, 2012, http://www.jsk.de/media.php/PDFs/04-Hochhaeuser/04-6%20Qipco%20Office%20Tower,Tornado,%20Doha,%20Qatar_Var2.pdf.
59. Accessed July 17, 2012, http://www.wicona.ie/en/Case-studies/Tornado-Tower-Doha-Qatar/Tornado-Tower---in-detail.
60. Ahmad Cheikha, Tornado Tower: Short note on the history. Document sent to the author by the architect on July 29, 2012.
61. "2009 best tall building Middle East & Africa," Council on Tall Buildings and Urban Habitat. Accessed July 17, 2012, http://www.ctbuh.org/Awards/AllPastWinners/09_TornadoTower/tabid/1040/language/en-GB/Default.aspx.
62. The author visited Katara Cultural Village on March 26, 2011.
63. Accessed July 14, 2012, http://www.katara.net/english/about-katara/about-us.
64. Ibid.
65. Accessed July 16, 2012, http://www.qf.org.qa/community-development/protecting-qatar-heritage/qatar-philharmonic-orchestra.
66. Accessed July 14, 2012, http://www.skyscrapercity.com/showthread.php?t=1309589.
67. Accessed July 14, 2012, http://www.ghd.com/global/projects/cultural-village.
68. "Regional and international cultures meet in Qatar's Katara culture village," Al-Shorfa.com, July 25, 2011. Accessed July 14, 2012, http://al-shorfa.com/en_GB/articles/meii/features/main/2011/07/25/feature-03.
69. Accessed July 17, 2012, http://www.catnaps.org/islamic/planning.html.
70. Sharon Nagy (2000), "Dressing up downtown: Urban development and government public image in Qatar," *City & Society*, 12(1), 125–147. Accessed July 17, 2012, http://jft-newspaper.aub.edu.lb/reserve/data/urpl665-mh-wk3/Nagi.pdf
71. Accessed July 17, 2012, http://www.catnaps.org/islamic/planning.html.
72. "Witness to History: Gerhard Foltin, Sheraton Doha," Global Traveler. Accessed July 17, 2012, http://globaltravelerusa.com/mag/witness-to-history-gerhard-foltin-sheraton-doha.
73. Lawrence Van Gelder, "Spring marathon in Paris," *New York Times*, April 11, 1982. Accessed July 17, 2012, http://www.nytimes.com/1982/04/11/travel/by-lawernce-van-gelder-spring-marathon-in-paris.html?pagewanted=all.
74. Accessed July 17, 2012, http://www.sheratondoha.com.
75. The author visited the Student Center on September 25. 2011.
76. Alicia Saucedo, Legorreta+Legorreta, e-mail to the author, December 13, 2010.
77. Accessed July 4, 2012, http://www.qatar.cmu.edu/4051/fast-facts.
78. Accessed July 4, 2012, http://www.qatar.cmu.edu/124/new-building.
79. Ibid.
80. Quoted in *The Aggie Platform*, 3(3), Engineering Building Celebration Special Issue 2007, p. 23. Accessed July 4, 2012, http://repository.qatar.tamu.edu/bitstream/handle/1969.2/159/AP_Building_v-3-n3_Special_07.pdf?sequence=1.

81. Ricardo Legorreta, "Praemium Imperiale." Accessed July 4, 2012, http://www.praemiumimperiale.org/en/laureate/architecture/item/251-architecture.
82. Accessed July 4, 2012, http://www.qatar.tamu.edu/about/quick-facts.
83. Accessed July 18, 2012, http://midmac.net/projects_details.asp?project_id=6&cat_id=4.
84. Accessed July 18, 2012, http://4ddoha.com/collection.
85. Jury citation, The Pritzker Architecture Prize. Accessed July 17, 2012, http://www.pritzkerprize.com/1987/jury-citation.
86. Kenzo Tange, Kenzo Tange and URTEC, 1946–1982 SD 8011, (Tokyo: Kajima Shuppankai, 1983).
87. "Souk Waqif, Aga Khan Award for Architecture." Accessed July 14, 2012, http://www.akdn.org/architecture/project.asp?id=3564.
88. Mohamed Ali Abdulla, in conversation with Ibrahim Al Jaidah, *In Conversation: On Artists' Impact on the City* [Video published by Mathafmodern March 29, 2012]. Accessed July 29, 2012, http://www.youtube.com/watch?v=y_wxrjhGUGE&feature=g-all-u&context=G23da9feFAAAAAAAACAA.
89. Speakers' bio, Qatar Urban Forum. Accessed July 14, 2012, http://www.qatarurbanforum.com/speaker-bio4.html.
90. "Extensive research behind Souq Waqif's new face," *The Peninsula*, June 3, 2009. Accessed July 14, 2012, http://iloveqatar.net/forum/read.php?28,8194.
91. The author visited the Qatar University campus on May 12, 2012.
92. "Qatar University," ArchNet Digital Library. Accessed July 19, 2012, http://archnet.org/library/sites/one-site.jsp?site_id=395.
93. "1983 Architect's Record, Aga Khan Trust for Culture." Accessed July 20, 2012, http://archnet.org/library/files/one-file.jsp?file_id=708.
94. "Two new buildings," *Campus Life Newsletter*, August 17, 2011. Accessed July 18, 2012, http://blogs.qu.edu.qa/campuslife/?p=402.
95. "1983 Architect's Record, Aga Khan Trust for Culture." Accessed July 20, 2012, http://archnet.org/library/files/one-file.jsp?file_id=708.
96. The author visited Mathaf on March 20, 2011, and on several other occasions thereafter.
97. The author visited the School of Foreign Service in Qatar on September 25, 2011.
98. "Georgetown begins transition into New Building," Georgetown University School of Foreign Service in Qatar, October 19, 2010. Accessed July 5, 2012, http://qatar.sfs.georgetown.edu/121537.html#.T_WZsxwsID0.
99. Alicia Saucedo, Legorreta+Legorreta, e-mail to the author, December 13, 2010.
100. The author visited Al Wakrah Heritage Village on October 21, 2012.
101. Mohamed Ali Abdulla, in conversation with the author, Doha, October 21, 2012.
102. Mohamed Ali Abdulla, e-mail to the author, October 25, 2012.
103. Mohamed Ali Abdulla, in conversation with the author, Doha, October 23, 2012.
104. Al-Qabib means "with the domes."
105. "500-year-old mosque restored and opened," A1SaudiArabia.com, February 28, 2012. Accessed <AQ: provide date of access> http://www.a1saudiarabia.com/1906-500-year-old-mosque-restored-and-opened. E-mail from Mohammed Ali Abdullah to the author with copy of an aerial photograph of Al-Jabri mosque in Hofuf, July 31, 2012.
106. E-mail from Mohammed Ali Abdullah to the author with photograph of mosque in Dhahran, demolished in the 1950s, July 31, 2012.
107. Aga Khan Award for Architecture, 2366. QAT, Architect's Record, 2001 Award Cycle. Document transmitted to the author by the Aga Khan Award for Architecture, July 26, 2012.
108. "Rebuilt Abu Al-Qabib mosque opens," *Gulf Times*, July 20, 2012. Accessed July 26, 2012, <AQ: Pls chk link – I get a file not found (404) msg>http://www.gulftimes.com/site/topics/printArticle.asp?cu_no=2&item_no=520068&version=1&template_id=47&parent_id=27.
109. Mohamed Ali Abdullah, telephone conversation with the author, July 30, 2012.
110. Mohamed Ali Abdullah, telephone conversation with the author, July 30, 2012.
111. The author visited the Omar ibn Al-Khattab mosque on May 18, 2012, and again on October 21, 2012.
112. Mohamed Ali Abdullah, text message to the author, October 23, 2012.
113. "National Theatre and Ministry of Information," ArchNet Digital Library. Accessed July 16, 2012, http://archnet.org/library/sites/one-site.jsp?site_id=404.
114. The author visited Our Lady of the Rosary Catholic church on May 17, 2012.
115. Accessed July 15, 2012, http://www.avona.org/qatar/qatar_about.htm.

Doha Golf Club

Peter Harradine, 1997

Doha Golf Club has a 7,312-yard 18-hole championship course and a floodlit 9-hole academy, or "executive," course for less-experienced golfers. The Club's Golf Academy is a teaching and practice facility with a driving range and chipping, putting, and bunker practice areas. There are eight artificial lakes on the course, which is dominated by an "Arabian-style" clubhouse. The 150-hectare (371-acre) site was planted with 5,000 shrubs and 6,000 trees, including 1,300 palm trees and 10,000 cacti imported from Arizona, about 65 of which are of the giant Saguaro variety.[176] Natural outcrops of eroded rock are included in the course. The clubhouse, designed to evoke a Qatari residence, also has Arabian-style interiors, with fountains and large areas covered in marble. The solid teak doors were imported from Thailand and carved in Doha. The interior of the clubhouse is relatively intimate in scale but includes bars and restaurants with outdoor terraces overlooking the course, as well as a pro shop.

Peter Harradine designed the course in 1994. Harradine, a third-generation golf course designer, was born in 1945 in Bern, Switzerland. He is the chief architect of Harradine Golf and has designed and codesigned over 180 golf courses in Europe, Africa, the Middle East, and Asia.[177] The Doha Golf Club was the first grass course created in Qatar. The Qatar Golf Association indicates that the first course created in the country was built in 1949 in Dukhan by the Iraq Petroleum Company.[178] Voted number two in the Middle East by *Golf Digest* (2009), the Doha Golf Club saw its fifteenth hole elected best-designed hole in the Middle East (2008).[179] The top event held at the Doha Golf Club since 1998 is the Qatar Masters, which attracts some of the best golfers from the European tour. The club is open to golfers who are members and to playing nonmembers. Approximately 320 golfers use it on a regular basis. There is an active membership of 600 and a waiting list of 100. The clubhouse was built in 1994–95, and the golf club, located near West Bay Lagoon, 8 kilometers (5 miles) north of the city center, opened in 1997. The design architect was Samir Daoud (Diar Consult). Diar Consult was the winner of an invited international design competition organized by the Ministry of Municipal Affairs and Agriculture, Building Projects Department, which was headed at that time by Ibrahim Al Jaidah (now principal of AEB in Doha). According to Peter Ellis, "The architectural style was largely guided by Ibrahim Jaidah."[180] The lead consultant for the project was Rice Perry Ellis (RPE), which in this instance means that the firm was responsible for the design coordination and the supervision of the construction. The club was originally owned by Qatar National Hotels Company (now called Katara Hospitality). The contractor for the project was Hamad Bin Khalid Contracting. The rather lush greenery of the Doha Golf Club is definitely a contrast to the neighboring desert landscape. Prior to the intervention of Peter Harradine, the site of the course was indeed desert. Architecturally speaking, the clubhouse is of interest as a compromise between regional residential designs and the requirements of a modern golf club. The entrance-side façade, with visibly raised "rampart" corners that immediately evoke the "Arabian" theme, is fairly closed and white, whereas the golf course side immediately opposite is more open, allowing some views to the course, in particular from the sheltered terraces.

Notes

1. The author visited the construction site of the MIA on several occasions and attended the opening in 2008. He is also the author of *Doha Museum of Islamic Art, Doha, Qatar* (Munich, Ger.: Qatar Museums Authority, Prestel Verlag, 2008).
2. I. M. Pei, in discussion with the author, New York, March 23, 2006.
3. Ibid.
4. Ibid.
5. Jean-Michel Wilmotte, in discussion with the author, Paris, December 15, 2006.
6. MIAP_Timeline_credits. Pei Partnership Architects, October 29, 2011.
7. "MIA opens Park to public on Friday," *The Penninsula*, January 4, 2012. Accessed July 12, 2012, http://www.thepeninsulaqatar.com/qatar/178292-mia-opens-park-to-public-on-friday.html
8. "Mas'ud III ke Minar," ArchNet Digital Library. Accessed July 13, 2012, http://archnet.org/library/sites/one-site.jsp?site_id=10541.
9. "The magnificent '7' adds an edge to Doha's gloss," *The Independent*, December 28, 2011. Accessed July 13, 2012, http://www.independent.co.uk/arts-entertainment/architecture/the-magnificent-7-adds-an-edge-to-dohas-gloss-6281994.html.
10. Ibid.
11. "Tomorrow's technology for the day after tomorrow: Stadia and infrastructure for the 2022 World Cup in Qatar," Plastruction, March/April 2011, p. 13. Accessed July 13, 2012, https://www.hbmedia.info/plastruction/assets/ebooks/PT201103,oiewndcqb43/files/pt201103.pdf.
12. The author visited Weill Cornell Medical College on November 24, 2010.
13. Quotes from *Weill Cornell Qatar Chronicle*, 1(4), December 2003. Accessed July 3, 2012, http://qatar-weill.cornell.edu/media/chronicle/pdfs/qatarChronicle_v1_n4.pdf.
14. The author visited the Ceremonial Court on November 24, 2010.
15. "State Mosque to be named after Imam Abdul Wahhab," *Gulf Times*, December 14, 2011. Accessed July 15, 2012, http://gulftimes.com/site/topics/article.asp?cu_no=2&item_no=475722&version=1&template_id=36&parent_id=16.
16. Mohamed Ali Abdullah, e-mail to the author, July 31, 2012.
17. Accessed July 15, 2012, http://www.qatartourism.gov.qa/pillars/index/1/culture/238.
18. Accessed July 15, 2012, http://catnaps.org/islamic/islaurb3.html#wah.
19. Mohamed Ali Abdullah, telephone conversation with the author, July 30, 2012
20. Accessed July 15, 2012, http://www.diwan.gov.qa/english/the_amir/the_amir_speeche_117.htm.
21. The author visited the Liberal Arts & Science building on November 24, 2010.
22. The author visited QNCC on September 25, 2011.
23. Accessed July 4, 2012, http://www.qatarconvention.com/site/en/Newsletters/The_Sidra_Signature.aspx.
24. Accessed July 10, 2012, http://www.isozakimaffei.it/ProjectDetails.aspx?IdProject=13.
25. CTBUH Nomination Form, Best Tall Building Award, April 30, 2012. Transmitted by the architects to the author, July 28, 2012.
26. "National Museum: Doha, Qatar, report by the Aga Khan Award for Architecture." Accessed September 14, 2012, http://www.akdn.org/architecture/pdf/0011_Qat.pdf
27. Salma Samar Damluji, *Al Diwan Al Amiria*, Doha, Qatar (London: Laurence King Publishing, 2011).
28. Florian Wiedmann, Ashraf M. Salama, Alain Thierstein, *Urban Evolution of the City of Doha: An Investigation into the Impact of Economic Transformations on Urban Structures*. Accessed July 21, 2012, jfa.arch.metu.edu.tr/archive/0258-5316/advop/35-61.pdf.
29. Samar Damluji, *Al Diwan Al Amiria*.
30. The author visited the Old Emiri Diwan on March 24, 2011.
31. Samar Damluji, *Al Diwan Al Amiria*.
32. Accessed July 21, 2012, http://www.catnaps.org/islamic/planning.html#dopal1.
33. Samar Damluji, *Al Diwan Al Amiria*.
34. Accessed September 14, 2012, http://catnaps.org/islamic/islaurb4.html.
35. Samar Damluji, *Al Diwan Al Amiria*.
36. The author visited the Ministry of Finance on May 17, 2012.
37. The author visited the New Doha International Airport on May 19, 2012.
38. Accessed July 24, 2012, http://www.bechtel.com/new_doha_airport.html.
39. Accessed July 24, 2012, http://www.ndiaproject.com/elements/7%20-%20Fascinating%20Facts.pdf.
40. "S.F. designers win airport work in Qatar: 'Eight-figure' deal," *San Francisco Business Times*. Accessed July 23, 2012, http://www.bizjournals.com/sanfrancisco/stories/2004/03/22/story6.html.
41. "Moly-grade stainless steel makes waves at Middle Eastern Airport," International Molybdenum Association. Accessed July 24, 2012, http://www.imoa.info/moly_uses/moly_grade_stainless_steels/architecture/doha_international_airport.php.
42. "Another airport contract for DCC in Doha, Qatar," *International Ropeway Review*. Accessed July 24, 2012, http://www.isr.at/Another-airport-contract-for-DCC.153+M52087573ab0.0.html.
43. Ali Moghaddasi, e-mail to the author, August 10, 2012.
44. Accessed July 23, 2012, http://www.ndiaproject.com/elements/9%20-%20Emiri%20Terminal.pdf
45. Accessed July 24, 2012, http://www.ghafari.com/content.cfm/middle-east.
46. Accessed July 20, 2012, http://www.coxarchitecture.com.au/#/project/11587.
47. Tristam Carfrae, Jane Nixon, Peter Macdonald (2006), "Khalifa Stadium, Doha, Qatar," *The Arup Journal* (2), pp. 44–50. Accessed July 21, 2012, www.arup.com/_assets/_download/download628.pdf.
48. 2022 FIFA World Cup Bid Evaluation Report: Qatar.
49. Accessed July 20, 2012, http://www.aspire.qa/Aboutus/OurHistory/Pages/OurHistory.aspx.
50. Accessed July 21, 2012, http://www.agencetaillibert.com/Ensemble_sportifs/Complexes_sportifs/Khalifa_Sport_City_Qatar.html.
51. "A sports paradise in the middle of the desert" [Press release], Alcoa Architectural Products. Accessed July 21, 2012, http://www.alcoa.com/aap/europe/en/news/releases/aap_aspire_dome.asp.
52. Accessed July 21, 2012, http://www.jtc-qa.com/html/cprojects.htm.
53. The author visited Al Shaqab Academy on September 25, 2011.
54. Accessed June 30, 2012, http://www.qf.org.qa/community-development/protecting-qatar-heritage/alshaqab/alshaqab.
55. Accessed July 10, 2012, http://www.alshaqab.com/about-us/interactive-map.
56. The author visited QSTP on September 25, 2011.
57. Accessed November 6, 2012, http://www.woodsbagot.com/en/Pages/QatarScienceTechnologyPark.aspx.
58. Accessed July 17, 2012, http://www.jsk.de/media.php/PDFs/04-Hochhaeuser/04-6%20Qipco%20Office%20Tower,Tornado,%20Doha,%20Qatar_Var2.pdf.
59. Accessed July 17, 2012, http://www.wicona.ie/en/Case-studies/Tornado-Tower-Doha-Qatar/Tornado-Tower---in-detail.
60. Ahmad Cheikha, Tornado Tower: Short note on the history. Document sent to the author by the architect on July 29, 2012.
61. "2009 best tall building Middle East & Africa," Council on Tall Buildings and Urban Habitat. Accessed July 17, 2012, http://www.ctbuh.org/Awards/AllPastWinners/09_TornadoTower/tabid/1040/language/en-GB/Default.aspx.
62. The author visited Katara Cultural Village on March 26, 2011.
63. Accessed July 14, 2012, http://www.katara.net/english/about-katara/about-us.
64. Ibid.
65. Accessed July 16, 2012, http://www.qf.org.qa/community-development/protecting-qatar-heritage/qatar-philharmonic-orchestra.
66. Accessed July 14, 2012, http://www.skyscrapercity.com/showthread.php?t=1309589.
67. Accessed July 14, 2012, http://www.ghd.com/global/projects/cultural-village.
68. "Regional and international cultures meet in Qatar's Katara culture village," Al-Shorfa.com, July 25, 2011. Accessed July 14, 2012, http://al-shorfa.com/en_GB/articles/meii/features/main/2011/07/25/feature-03.
69. Accessed July 17, 2012, http://www.catnaps.org/islamic/planning.html.
70. Sharon Nagy (2000), "Dressing up downtown: Urban development and government public image in Qatar," *City & Society*, 12(1), 125–147. Accessed July 17, 2012, http://jft-newspaper.aub.edu.lb/reserve/data/urpl665-mh-wk3/Nagi.pdf
71. Accessed July 17, 2012, http://www.catnaps.org/islamic/planning.html.
72. "Witness to History: Gerhard Foltin, Sheraton Doha," Global Traveler. Accessed July 17, 2012, http://globaltravelerusa.com/mag/witness-to-history-gerhard-foltin-sheraton-doha.
73. Lawrence Van Gelder, "Spring marathon in Paris," *New York Times*, April 11, 1982. Accessed July 17, 2012, http://www.nytimes.com/1982/04/11/travel/by-lawernce-van-gelder-spring-marathon-in-paris.html?pagewanted=all.
74. Accessed July 17, 2012, www.sheratondoha.com.
75. The author visited the Student Center on September 25. 2011.
76. Alicia Saucedo, Legorreta+Legorreta, e-mail to the author, December 13, 2010.
77. Accessed July 4, 2012, http://www.qatar.cmu.edu/4051/fast-facts.
78. Accessed July 4, 2012, http://www.qatar.cmu.edu/124/new-building.
79. Ibid.
80. Quoted in *The Aggie Platform*, 3(3), Engineering Building Celebration Special Issue 2007, p. 23. Accessed July 4, 2012, http://repository.qatar.tamu.edu/bitstream/handle/1969.2/159/AP_Building_v-3-n3_Special_07.pdf?sequence=1.
81. Ricardo Legorreta, "Praemium Imperiale." Accessed July 4, 2012, http://www.praemiumimperiale.org/en/laureate/architecture/item/251-architecture.
82. Accessed July 4, 2012, http://www.qatar.tamu.edu/about/quick-facts.
83. Accessed July 18, 2012, http://midmac.net/projects_details.asp?project_id=6&cat_id=4.
84. Accessed July 18, 2012, http://4ddoha.com/collection.
85. Jury citation, The Pritzker Architecture Prize. Accessed July 17, 2012, http://www.pritzkerprize.com/1987/jury-citation.
86. Kenzo Tange, Kenzo Tange and URTEC, 1946–1982 SD 8011, (Tokyo: Kajima Shuppankai, 1983).
87. "Souk Waqif, Aga Khan Award for Architecture." Accessed July 14, 2012, http://www.akdn.org/architecture/project.asp?id=3564.
88. Mohamed Ali Abdulla, in conversation with Ibrahim Al Jaidah, *In Conversation: On Artists' Impact on the City* [Video published by Mathafmodern March 29, 2012]. Accessed July 29, 2012, http://www.youtube.com/watch?v=y_wxrjhGUGE&feature=g-all-u&context=G23da9feFAAAAAAAACAA.
89. Speakers' bio, Qatar Urban Forum. Accessed July 14, 2012, http://www.qatarurbanforum.com/speaker-bio4.html.
90. "Extensive research behind Souq Waqif's new face," *The Peninsula*, June 3, 2009. Accessed July 14, 2012, http://iloveqatar.net/forum/read.php?28,8194.
91. The author visited the Qatar University campus on May 12, 2012.
92. "Qatar University," ArchNet Digital Library. Accessed July 19, 2012, http://archnet.org/library/sites/one-site.jsp?site_id=395.
93. "1983 Architect's Record, Aga Khan Trust for Culture." Accessed July 20, 2012, http://archnet.org/library/files/one-file.jsp?file_id=708.
94. "Two new buildings," *Campus Life Newsletter*, August 17, 2011. Accessed July 18, 2012, http://blogs.qu.edu.qa/campuslife/?p=402.
95. "1983 Architect's Record, Aga Khan Trust for Culture." Accessed July 20, 2012, http://archnet.org/library/files/one-file.jsp?file_id=708.
96. The author visited Mathaf on March 20, 2011, and on several other occasions thereafter.
97. The author visited the School of Foreign Service in Qatar on September 25, 2011.
98. "Georgetown begins transition into New Building," Georgetown University School of Foreign Service in Qatar, October 19, 2010. Accessed July 5, 2012, http://qatar.sfs.georgetown.edu/121537.html#.T_WZsxwsID0.
99. Alicia Saucedo, Legorreta+Legorreta, e-mail to the author, December 13, 2010.
100. The author visited Al Wakrah Heritage Village on October 21, 2012.
101. Mohamed Ali Abdulla, in conversation with the author, Doha, October 21, 2012.
102. Mohamed Ali Abdulla, e-mail to the author, October 25, 2012.
103. Mohamed Ali Abdulla, in conversation with the author, Doha, October 23, 2012.
104. Al-Qabib means "with the domes."
105. "500-year-old mosque restored and opened," A1SaudiArabia.com, February 28, 2012. Accessed <AQ: provide date of access> http://www.a1saudiarabia.com/1906-500-year-old-mosque-restored-and-opened. E-mail from Mohammed Ali Abdullah to the author with copy of an aerial photograph of Al-Jabri mosque in Hofuf, July 31, 2012.
106. E-mail from Mohammed Ali Abdullah to the author with photograph of mosque in Dhahran, demolished in the 1950s, July 31, 2012.
107. Aga Khan Award for Architecture, 2366. QAT, Architect's Record, 2001 Award Cycle. Document transmitted to the author by the Aga Khan Award for Architecture, July 26, 2012.
108. "Rebuilt Abu Al-Qabib mosque opens," *Gulf Times*, July 20, 2012. Accessed July 26, 2012, <AQ: Pls chk link – I get a file not found (404) msg>http://www.gulftimes.com/site/topics/printArticle.asp?cu_no=2&item_no=520068&version=1&template_id=47&parent_id=27.
109. Mohamed Ali Abdullah, telephone conversation with the author, July 30, 2012.
110. Mohamed Ali Abdullah, telephone conversation with the author, July 30, 2012.
111. The author visited the Omar ibn Al-Khattab mosque on May 18, 2012, and again on October 21, 2012.
112. Mohamed Ali Abdullah, text message to the author, October 23, 2012.
113. "National Theatre and Ministry of Information," ArchNet Digital Library. Accessed July 16, 2012, http://archnet.org/library/sites/one-site.jsp?site_id=404.
114. The author visited Our Lady of the Rosary Catholic church on May 17, 2012.
115. Accessed July 15, 2012, http://www.avona.org/qatar/qatar_about.htm.

116. "Qatar opens first church, quietly," *Aljazeera*. Accessed July 15, 2012, http://www.aljazeera.com/news/middleeast/2008/03/2008525173738882540.html.
117. Accessed July 15, 2012, http://www.rosarychurchqatar.com/index.php.
118. "First Roman Catholic church opens in Qatar," *USA Today*. Accessed July 15, 2012, http://www.usatoday.com/news/religion/2008-03-15-qatar-catholicchurch_N.htm.
119. "La prima chiesa cattolica del Qatar." Accessed July 15, 2012, http://www.santinazaroccelsobresso.it/sito/documenti/Squilla/LI_6_qatar.pdf.
120. Accessed July 15, 2012, from http://www.avona.org/events/stained_glass_windows_rosay_church.htm.
121. "Qatar leads regional efforts to protect athletes' health by launching Anti-Doping Laboratory." Accessed July 18, 2012, http://www.qatartourism.gov.qa/press/index/1/73.
122. Accessed April 14, 2012, http://www.qmdi.com.qa/output/page446.asp.
123. Dr. Muhammed Al-Sayrafi, general manager, Anti-Doping Lab Qatar, in conversation with the author, Doha, February 13, 2012. The author visited the exterior of the building on that day.
124. Albert de Pineda Álvarez, e-mail to the author, July 19, 2012.
125. The author visited the Sidra Center construction site on September 25, 2011.
126. Sidra Medical and Research Center, Pelli Clarke Pelli Architects. Accessed July 10, 2012, http://pcparch.com/project/sidra-medical-and-research-center.
127. Accessed July 23, 2012, http://qatar-weill.cornell.edu/aboutUs/overview/hamad.html.
128. John Lambert-Smith, in conversation with the author, Doha, February 14, 2012.
129. Accessed July 16, 2012, http://www.ghd.com/global/projects/al-wakrah-hospital.
130. Accessed July 16, 2012, http://www.ashghal.gov.qa/English/Ashghal/Pages/default.aspx.
131. Accessed July 16, 2012, http://www.jandp-group.com/project.asp?pid=966&id=2.
132. Accessed July 16, 2012, http://www.jandp-group.com/default.asp?id=11&mid=1&SID=53678192783654100 9283465
133. Accessed July 23, 2012, http://almanadesignconsultants.com/index.php?page=show_project&id=18.
134. Accessed July 23, 2012, http://www.midmac.net/projects_details.asp?project_id=56&cat_id=12.
135. Accessed July 22, 2012, http://www.news-medical.net/news/20100621/Al-Amal-Hospital-in-Qatar-commences-treatment-with-Varians-RapidArc-radiotherapy.aspx?page=2.
136. Accessed July 23, 2012, http://www.gulf-times.com/site/topics/article.asp?cu_no=2&item_no=472788&version=1&template_id=36&parent_id=16.
137. Accessed July 23, 2012, http://www.gulf-times.com/site/topics/article.asp?cu_no=2&item_no=438062&version=1&template_id=57&parent_id=56.
138. Accessed July 18, 2012, http://www.aecom.com/What+We+Do/Architecture/Market+Sectors/Health+Care/_carousel/ASPETAR+Qatar+Orthopaedic+and+Sports+Medicine+Hospital.
139. The author visited ASPETAR on March 21, 2011.
140. Accessed July 18, 2012, http://www.aspetar.com/Overview.aspx.
141. Accessed July 18, 2012, http://www.ellerbebecket.com/success/newsitem/228/Qatar_Takes_Sports_Training_and_Rehab_to_New_Level_With_Khalifa_Orthopedic_Sports_Medicine_Hospital.html.
142. Msheireb Properties, Msheireb Downtown Doha: Project profile.
143. Accessed July 24, 2012, http://www.msheireb.com/company.html.
144. Tim Makower, "Doha Renaissance: Msheireb Re-born," October 17, 2011. Text transmitted to the author by e-mail by Prof. Makower, July 24, 2012.
145. The author visited the Pearl-Qatar on September 29, 2011.
146. Accessed November 4, 2012, http://www.constructionweekonline.com/projects-55-the-pearl-qatar.
147. Accessed July 22, 2012, http://www.thepearlqatar.com/SubTemplate1.aspx?ID=144&MID.
148. Accessed July 23, 2012, http://www.callison.com/index.php/the-pearl-porto-arabia.
149. The author visited the General Post Office on May 17, 2012.
150. Accessed July 18, 2012, http://www.catnaps.org/islamic/islaurb3.html.
151. Accessed July 18, 2012, http://www.qatarposts.com/gpc/headoffice.htm.
152. Accessed July 18, 2012, http://www.qatarposts.com/gpc/history.htm.
153. Accessed July 18, 2012, http://www.emporis.com/building/dohageneralpostoffice-doha-qatar.
154. Accessed July 18, 2012, http://www.qatarposts.com/gpc/headoffice.htm.
155. Accessed July 17, 2012, http://globaltravelerusa.com/mag/witness-to-history-gerhard-foltin-sheraton-doha.
156. Accessed July 18, 2012, http://www.ghd.com/global/projects/grand-hyatt-resort.
157. Accessed July 18, 2012, http://www.gulf-times.com/site/topics/article.asp?cu_no=2&item_no=253304&version=1&template_id=36&parent_id=16.
158. "Grand Hyatt Doha opens in vibrant Qatari capital" [Press release], Reuters, March 22, 2009. Accessed July 18, 2012, http://www.reuters.com/article/2009/03/22/idUS25117+22-Mar-2009+BW20090322.
159. "Region inspired paintings for Grand Hyatt rooms," *Gulf Times*, December 21, 2008. Accessed July 18, 2012, http://www.gulf-times.com/site/topics/article.asp?cu_no=2&item_no=262041&version=1&template_id=36&parent_id=16.
160. The author has stayed in Al Sharq Village during several visits to Doha in 2011 and 2012.
161. AEB-Qatar, e-mail to the author, July 24, 2012.
162. Ibid.
163. The author visited the Awsaj Institute on February 13, 2012.
164. Accessed July 9, 2012, https://www.cna-qatar.com/AboutCNAQ/Pages/Campus.aspx.
165. "College of the North Atlantic, Qatar by Woods Bagot," Australian Institute of Architects. Accessed July 9, 2012, http://www.architecture.com.au/awards_search?option=showaward&entryno=2007190741.
166. The author visited the campus of the American School of Doha on May 20, 2012.
167. "Qatar, Doha: American School of Doha," U.S. Department of State. Accessed on July 23, 2012, http://www.state.gov/m/a/os/1515.htm.
168. The information in this paragraph comes essentially from the website of the American School of Doha. Accessed July 24, 2012, http://www.asd.edu.qa/page.cfm?p=360.
169. Ibid.
170. Edwin Ladd, quoted in "American school hopes to be among the world's top five," *Gulf Times*, February 12, 2007. Accessed July 23, 2012, http://www.gulf-times.com/site/topics/article.asp?cu_no=2&item_no=132406&version=1&template_id=36&parent_id=16.
171. The author visited Losail International Circuit on May 18, 2012.
172. Accessed July 22, 2012, http://motogptale.blogspot.ch/2011/03/track-info-losail-international-circuit.html.
173. Marielou Cruz, deputy general manager and personal assistant to QMMF president, e-mail to the author, July 24, 2012.
174. Accessed July 24, 2012, http://www.cicoconsultants.com/projects.
175. Accessed July 20, 2012, http://www.circuitlosail.com/index.php?page=circuit-info.
176. Accessed August 2, 2012, http://www.dohagolfclub.com/doha-golf-club-1.htm.
177. Accessed July 20, 2012, http://www.eigca.org/%5CMemberDetail.ink?MemberID=13&=&SelectFieldName=&SearchCrit=&Name=Peter%20Harradine.
178. Accessed August 4, 2012, http://www.top100golfcourses.co.uk/htmlsite/country.asp?id=70.
179. Accessed August 3, 2012, http://www.harradine-golf.com/images/downloads/hg_reflist.pdf.
180. Peter Ellis, e-mail to the author, August 7, 2011.

The author wishes to thank Her Excellency Sheikha Al Mayassa bint Hamad bin Khalifa Al Thani for having had the idea of this book. Thanks also go to Sheikh Fahad Al Thani who was most helpful for the organization of visits of all the buildings. My gratitude also to Roger Mandle, Ed Dolman, Jasper Hwang, Tim Makower, Mohammed Ali Abdulla, Yaffa Assouline, Philip Jon Lawrie, Charles Miers, and Ellen Cohen.

The publisher wishes to thank Viviane Hamza for her translation into Arabic and Salam Hamza for typesetting the Arabic edition.

First published in the United States
of America in 2014 by

SKIRA RIZZOLI PUBLICATIONS, INC.
300 Park Avenue South
New York, NY 10010
www.rizzoliusa.com

in association with

QATAR MUSEUMS
Copyright © 2014 - Doha - Qatar
www.qm.org.qa

Preface copyright © 2014 **H.E. Sheikha Al Mayassa bint Hamad bin Khalifa Al Thani**
Text by **Philip Jodidio** copyright © 2014 Philip Jodidio
All photographs copyright © 2014 **Roland Halbe**

All rights reserved. No part of this publication may be reproduced, stored in a retrieval system, or transmitted in any form or by any means, electronic, mechanical, photocopying, recording, or otherwise, without prior consent of the publisher.

2014 2015 2016 2017 2018 / 10 9 8 7 6 5 4 3 2 1

Library of Congress Control Number: 2014953881
ISBN: 978-0-8478-4111-0 (English hardcover)
ISBN: 978-0-8478-4693-1 (Arabic hardcover)

For Skira Rizzoli Publications, Inc.:
Charles Miers, Publisher
Margaret Chace, Associate Publisher
Ellen Cohen, Project Editor

For Qatar Museums:
Yaffa Assouline, Creative Art Director
Designed by **Philipp Roberts**

Translated by **Viviane Hamza**

Printed in China